WINDSOR THEN

A PICTORIAL ESSAY OF
WINDSOR ONTARIO'S GLORIOUS PAST

FROM THE ARCHIVES OF
WALKERVILLE PUBLISHING INC.

WalkervillePublishing

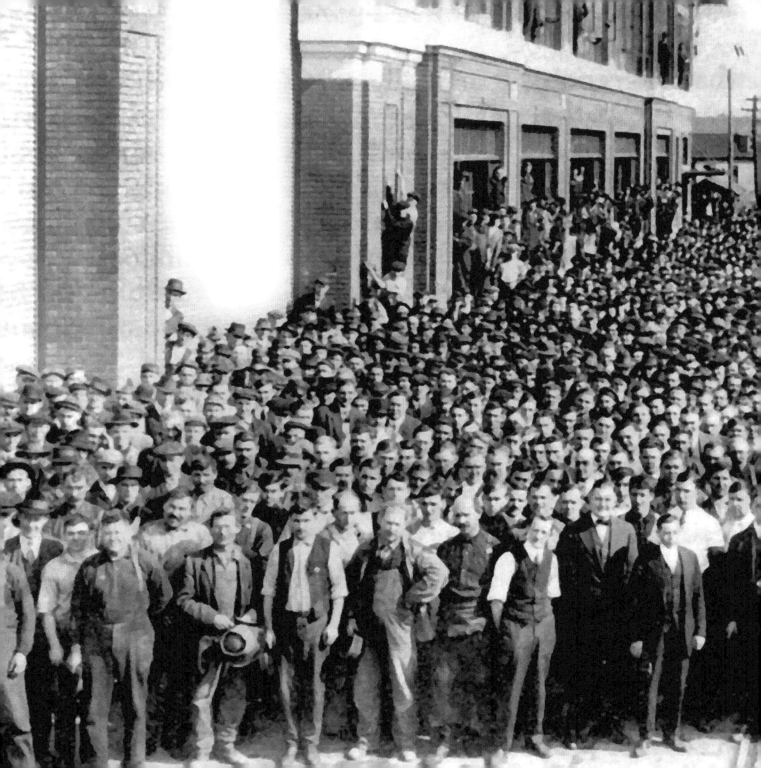

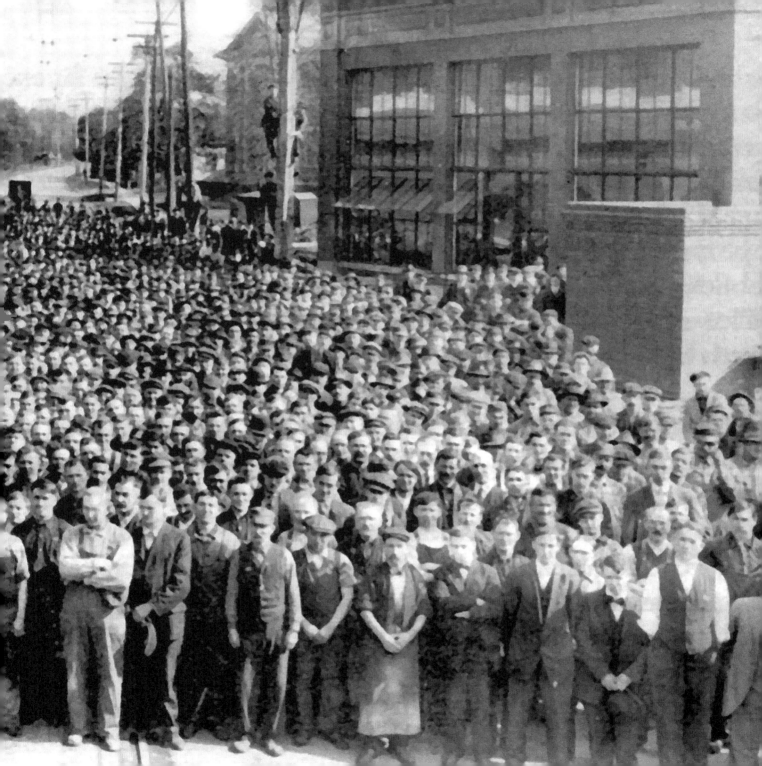

Which dreams indeed are ambition,

for the very Substance of the ambitious

is merely the shadow of a dream.

William Shakespeare

Overleaf: More than 1,700 Ford Motor Company Workers gather for group photo during World War I.

Design and Photo Editing by Chris Edwards
Edited By Elaine Weeks

©2011 Walkerville Publishing Inc.

all rights reserved

To purchase reproductions of any these images, contact us at:

519-255-9898
chris@walkerville.com

At the dawn of the industrial era in the 19th century, the Border Cities running along the straits between Lakes Erie and St-Clair were little more than primitive outposts in what was then Upper Canada. Remarkably, this region would transform into a world-leader in manufacturing and engineering innovation, with a particular emphasis on automotive production.

Simultaneously, advances in photographic glass plate and printing technologies – particularly by Louis Daguerre and George Eastman – would afford future generations a means to go back in time to witness an incredibly accurate journey of days gone by, unprecedented in the annals of mankind.

One of the greatest photographers of his day, Henri Cartier-Bresson, noted:

> "Photographers deal in things which are continually vanishing and when they have vanished there is no contrivance on earth which can make them come back again."

This new catalogue of old images contain several photos taken by professional photographers who sold them for postcards (the most popular way to communicate before the telephone) or for special edition projects by the corporate giants of the day, particularly the Ford Motor Company and Hiram Walker & Sons, who seemed to have a sense of its place in history; others found their way into newspapers or commemorative books as "slices in time"; the remainder are a mishmash of studio portraits and personal snapshots from local family archives.

"Windsor Then" provides an important piece of the puzzle that connects to our past. You may recognize images from one of our previous works, including our highly popular but now defunct publications, "The Walkerville Times," and "The Times Magazine", as well as our best-selling books, "Best of the Times Magazine," (2004 and 2005 editions) and "Postcards from The Past: Windsor & The Border Cities."

A virtual treasure trove, these photos came into our possession from a variety of sources, including the Ford Motor Company Archives, Windsor's Community Museum, and Hiram Walker & Sons archives; but mostly they arrived via readers, including amateur historians Charlie Fox and Bernie Drouillard, who wished them placed into this "time capsule" for future generations to appreciate.

To that end, we hope you thoroughly enjoy your journey through our pictorial "wayback machine."

Visit us on the web to learn more about this region's colourful past:

windsorthenwindsornow.com

walkervilletimes.com

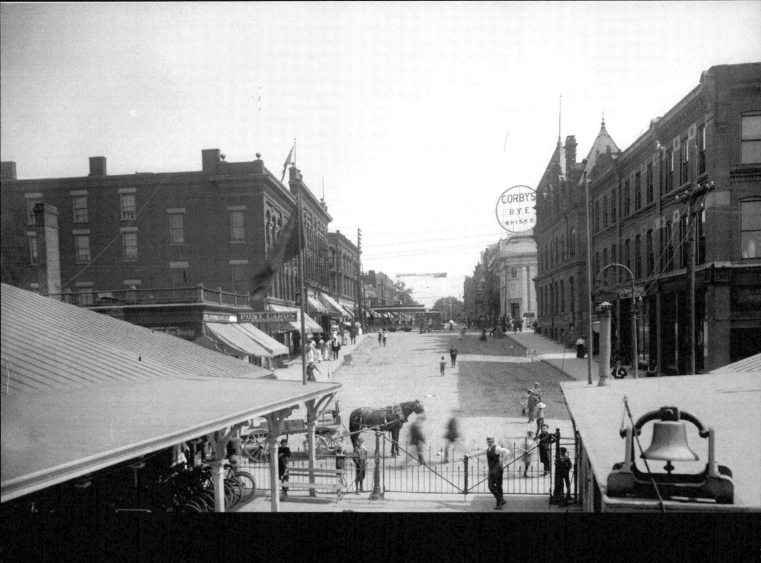

Windsor's Ferry Hill, foot of Ouellette and Sandwich (Riverside), 1910

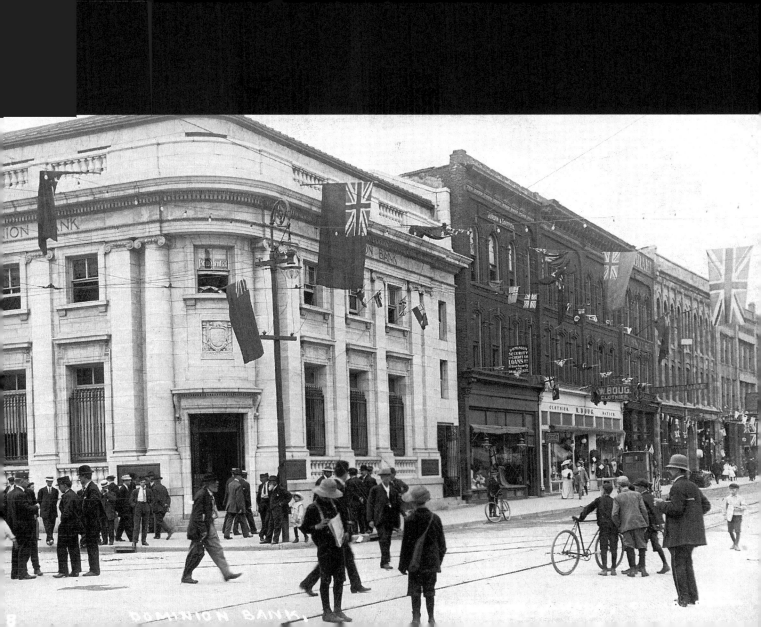

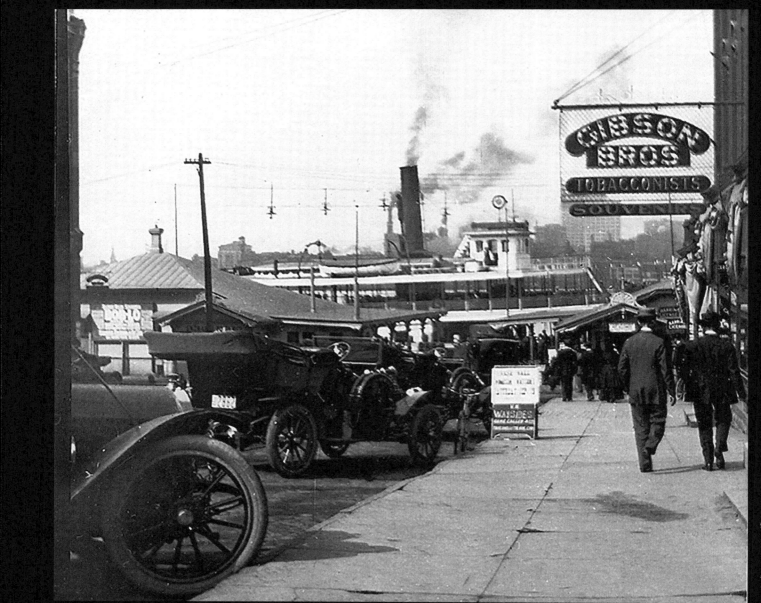

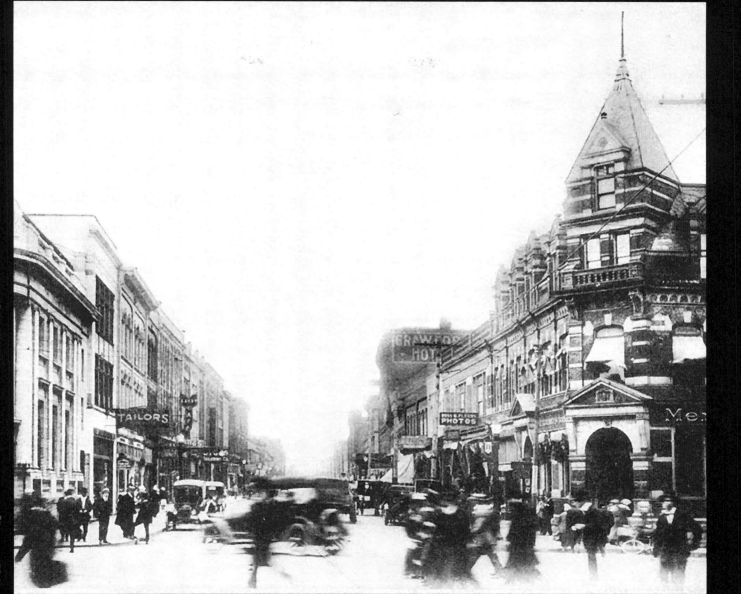

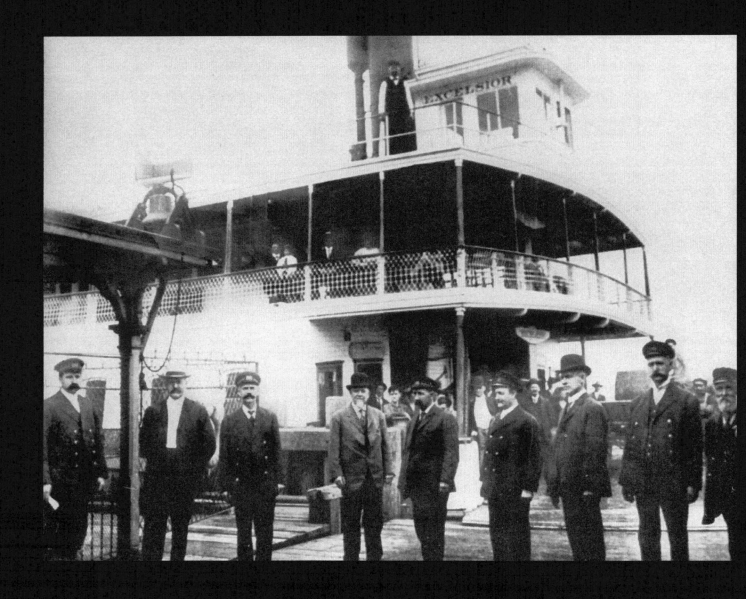
Riverboat Captain and Crew, 1890s

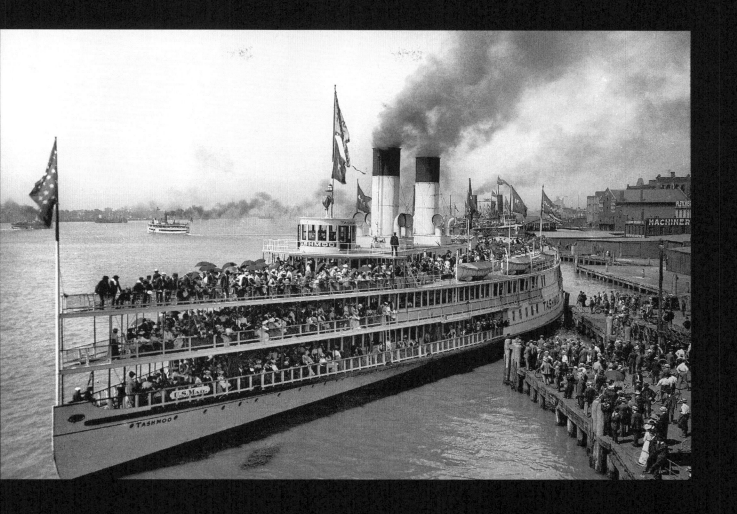

Pleasure Steamer Tashmoo, Port of Detroit

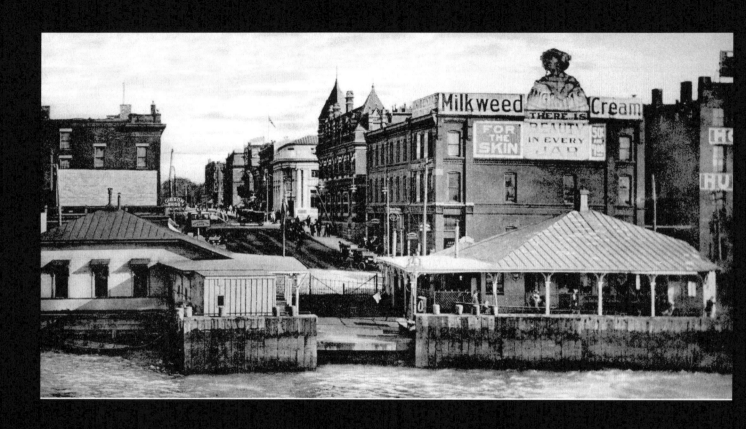

Windsor's Ferry Hill, 1910

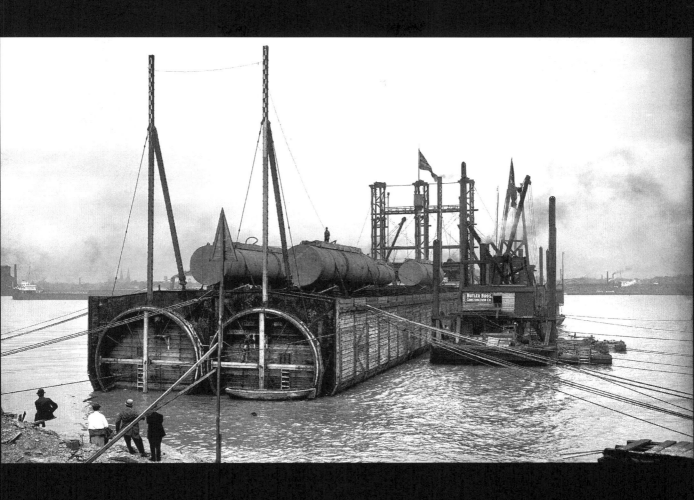
Sinking Rail Tunnel Tubes, Detroit River, 1909

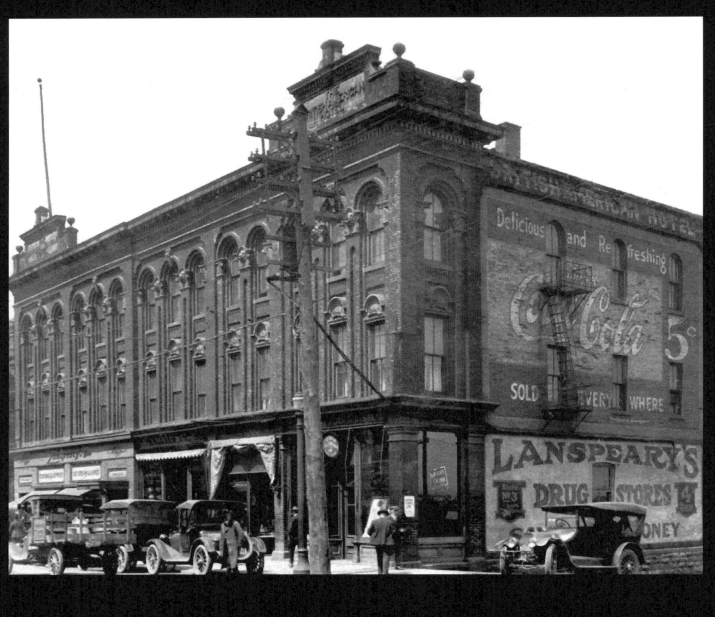

British American Hotel, Ferry Hill, Ouellette and Riverside, 1915

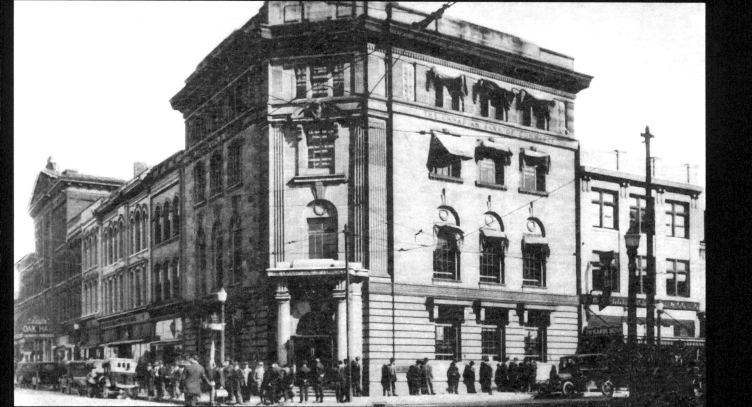

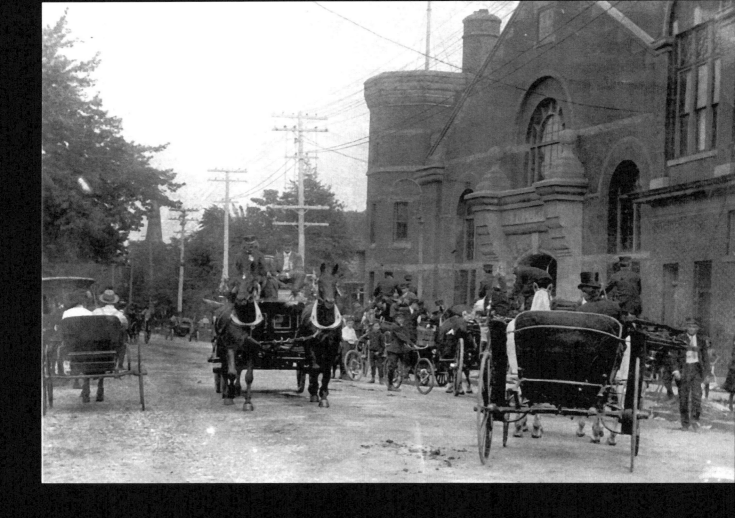
Parade Day, Windsor Armouries, 1906

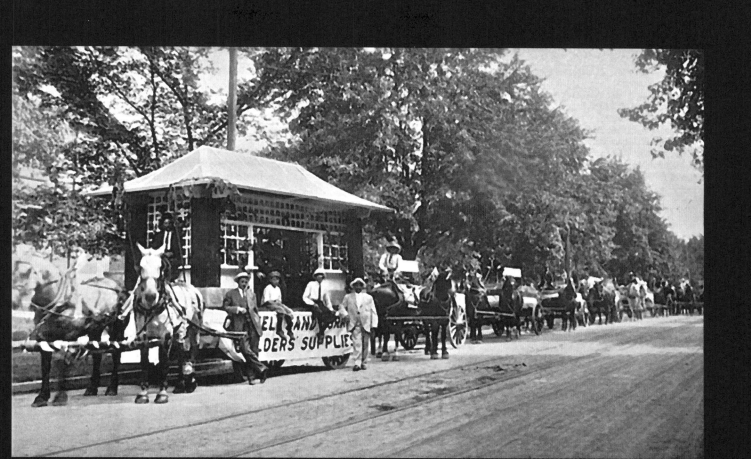

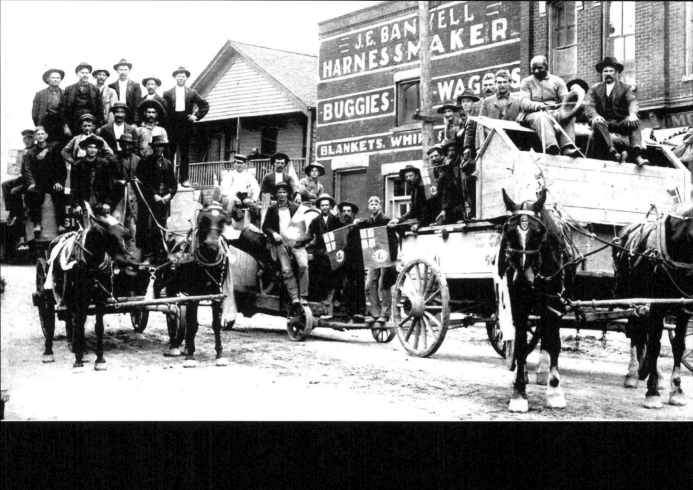

Moving Day, 1890s

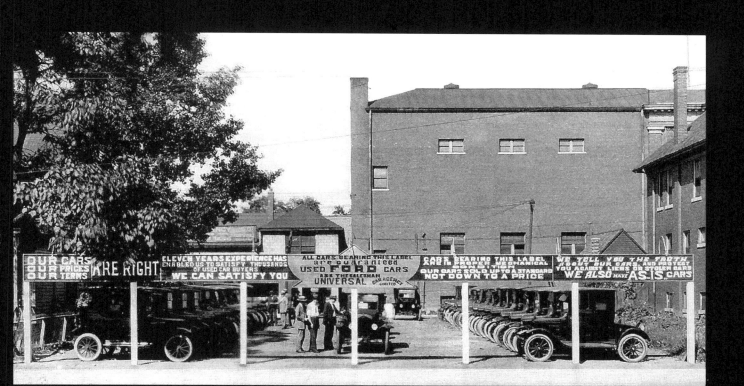

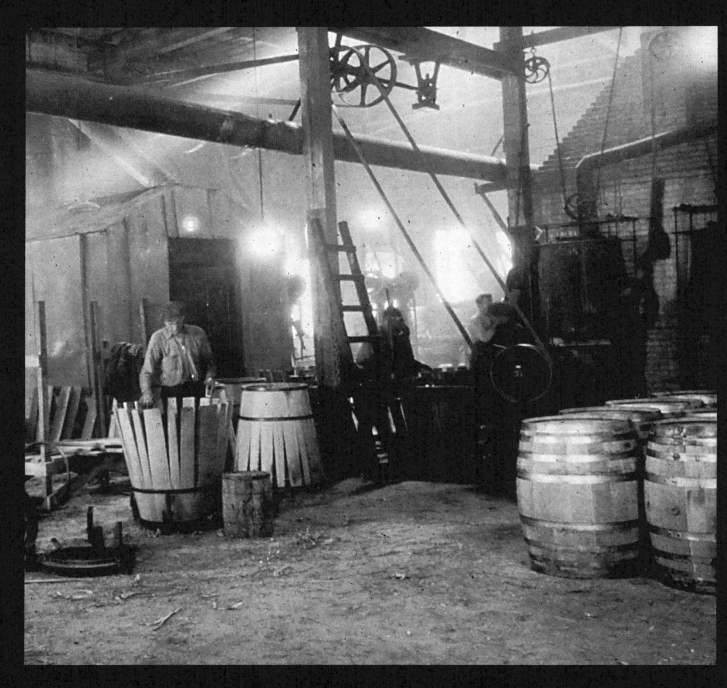

Cooper, Hiram Walker & Sons

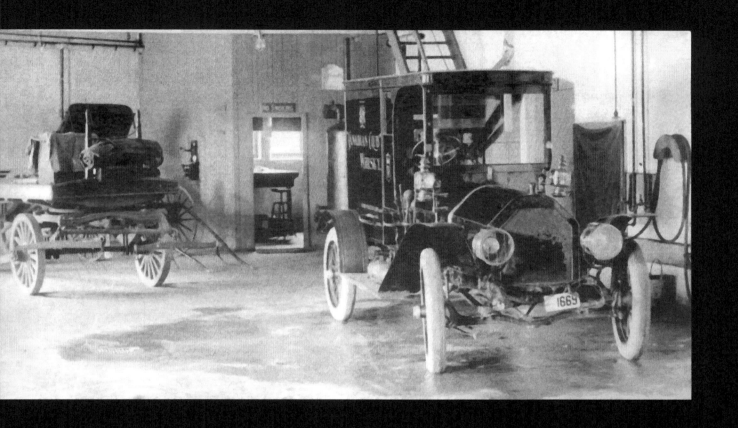

Car & Buggy, Hiram Walker & Sons

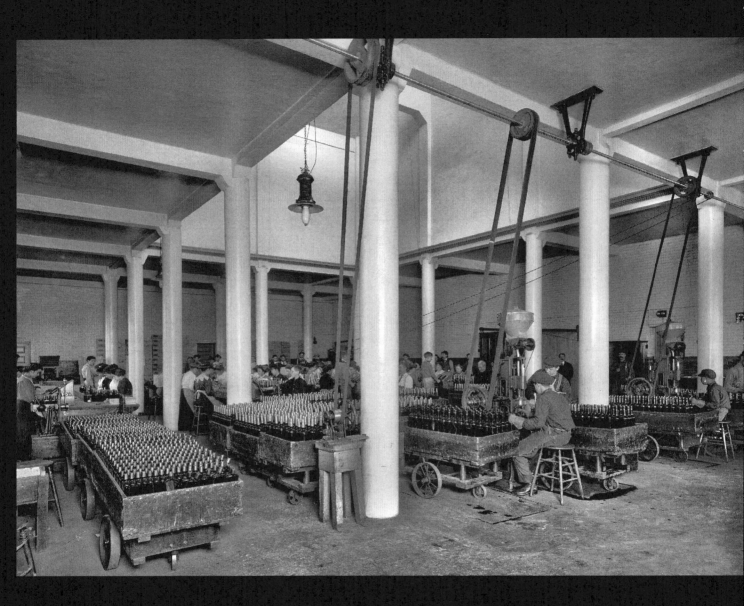

Canadian Club Bottling Line, 1899

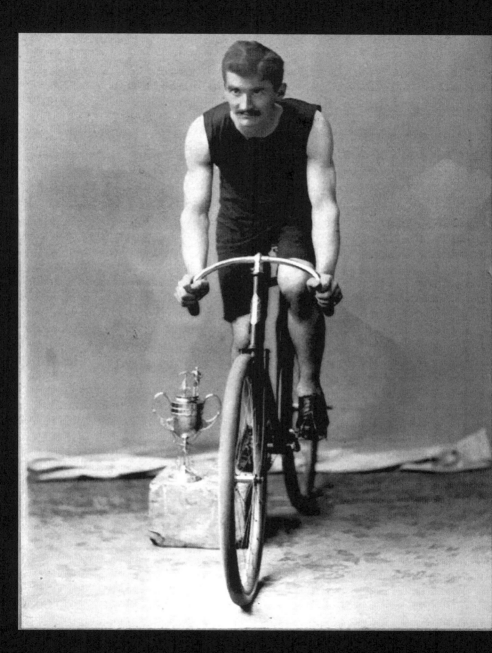

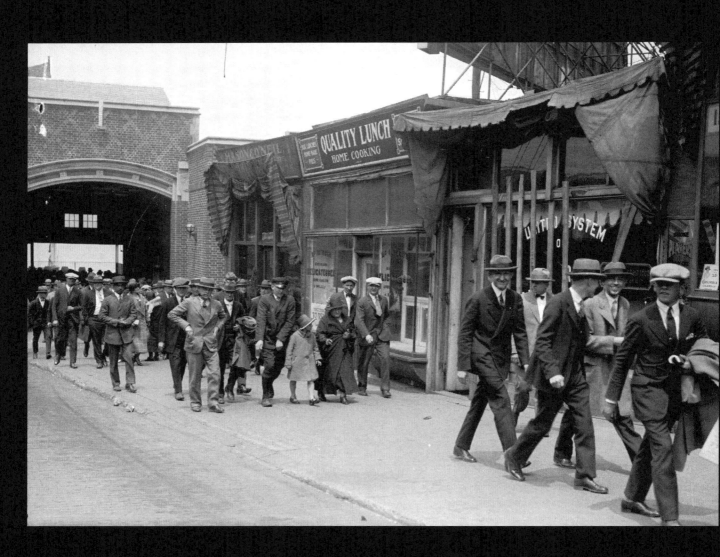

Crossing The Border to Ferry Hill, 1920s

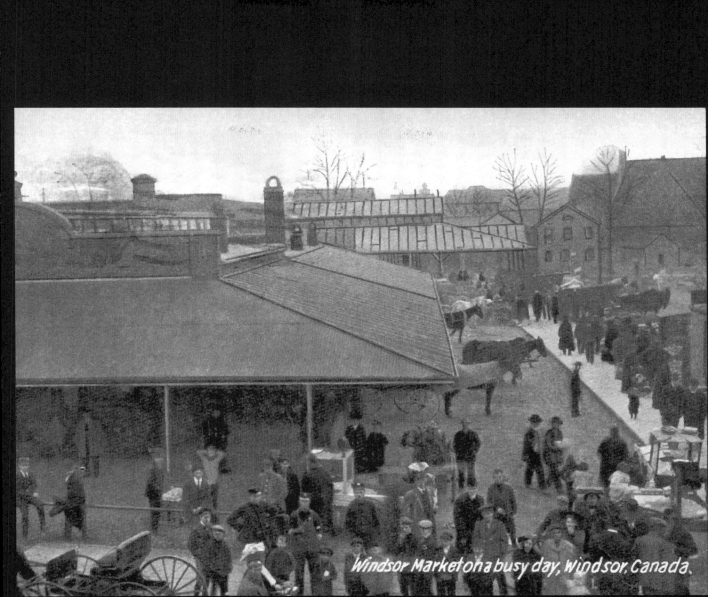

Fill 'er Up Right on Pitt Street

Made in Walkerville
Seagraves Fire Truck

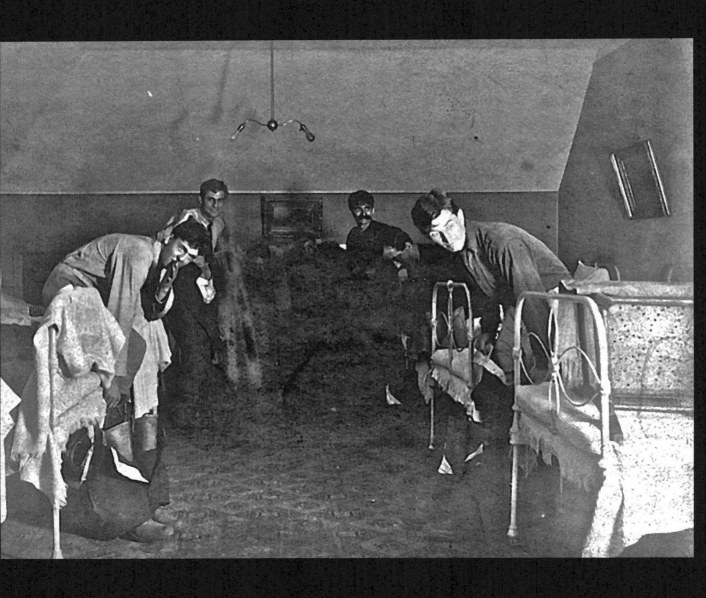

Up and At 'Em: Walkerville Fire Department, 1910

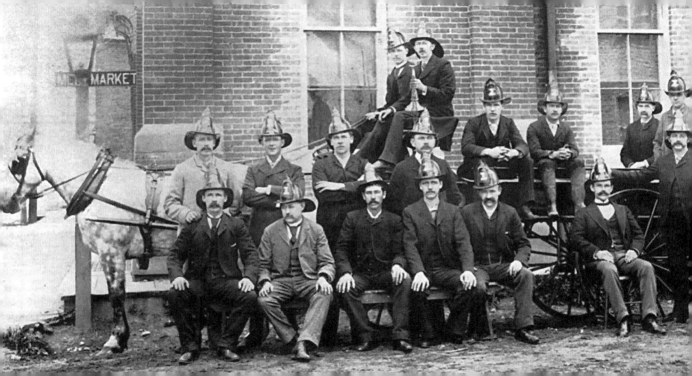

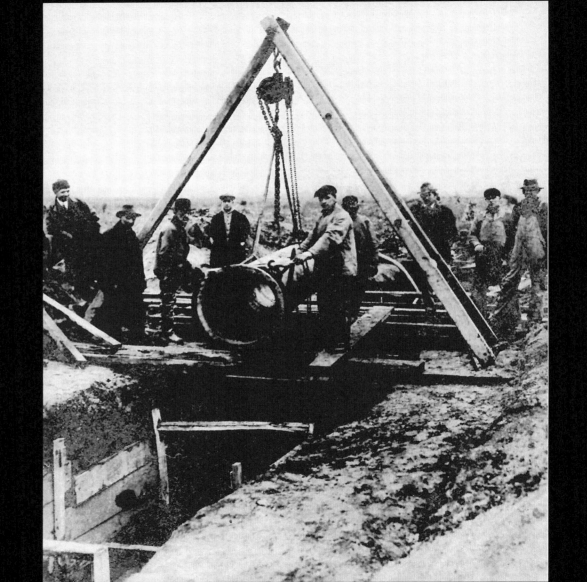

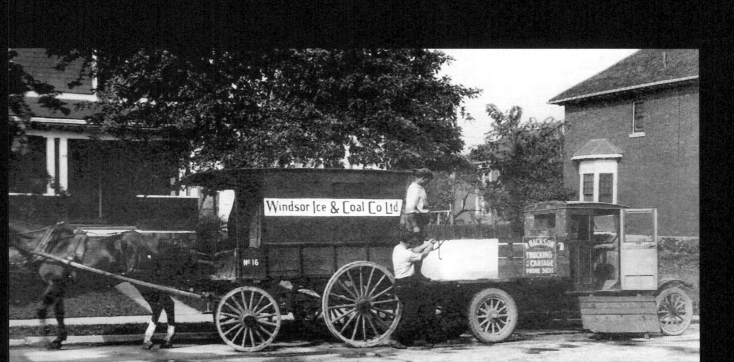

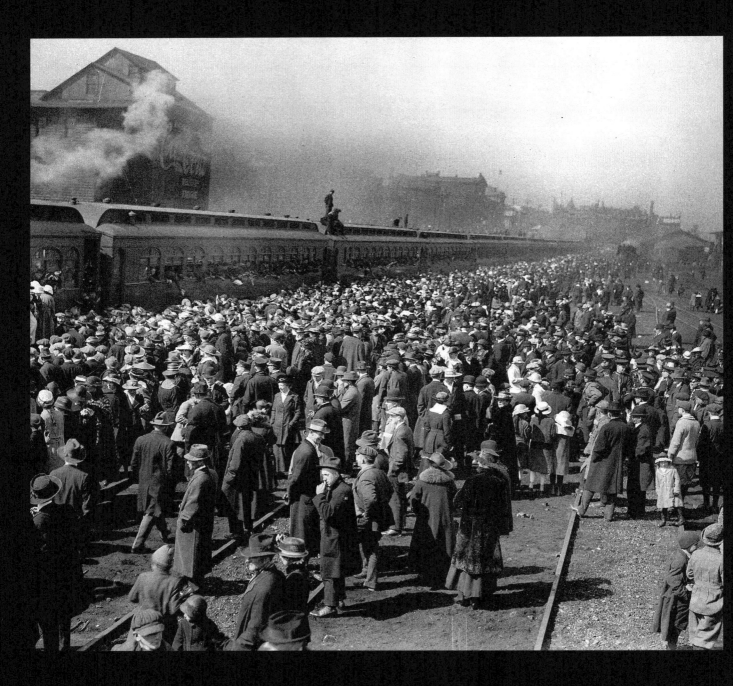

Off To World War I, Windsor Waterfront

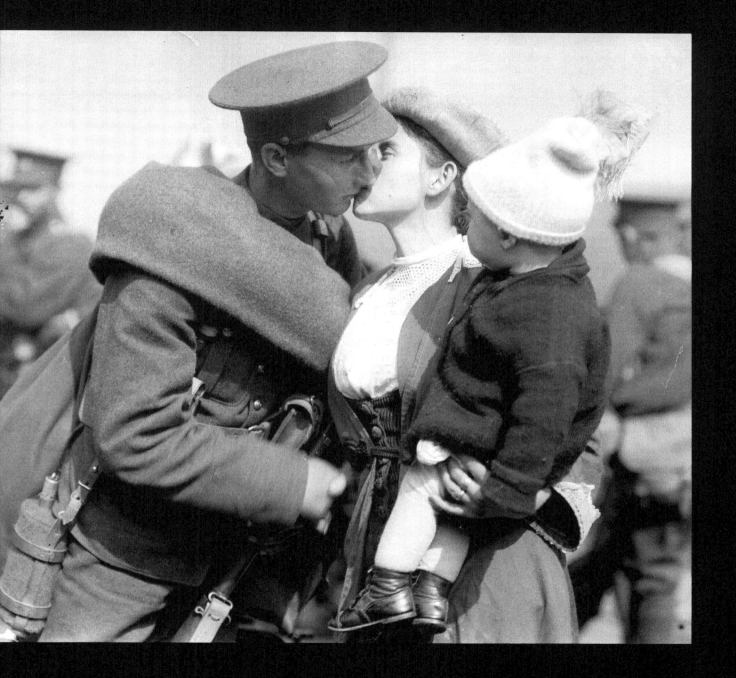

Goodbye Kiss, WW I

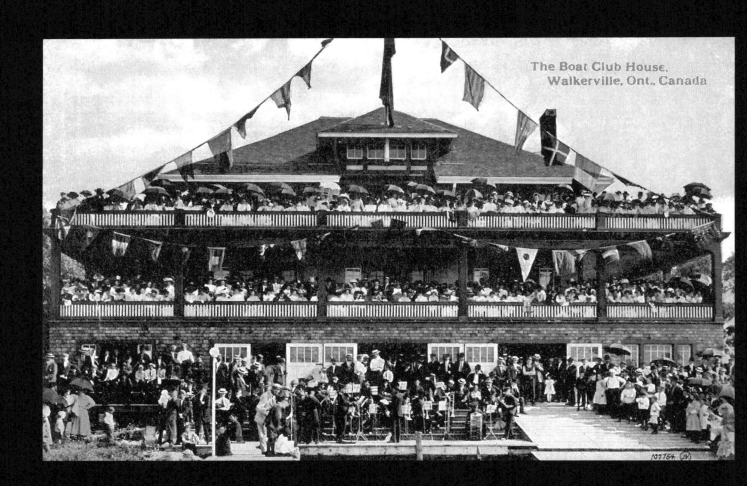

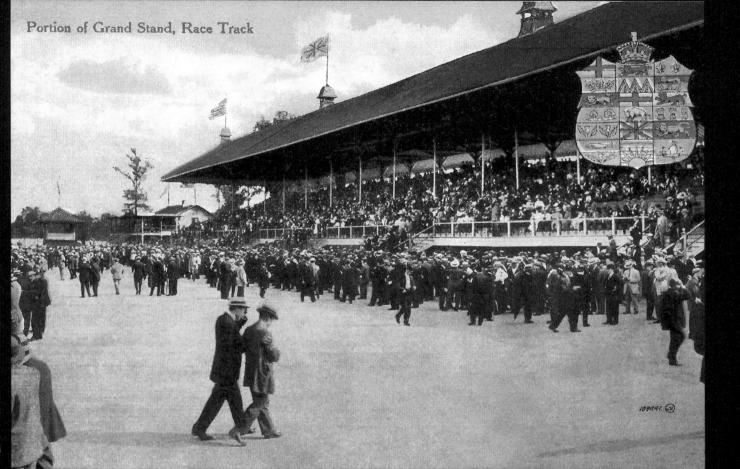

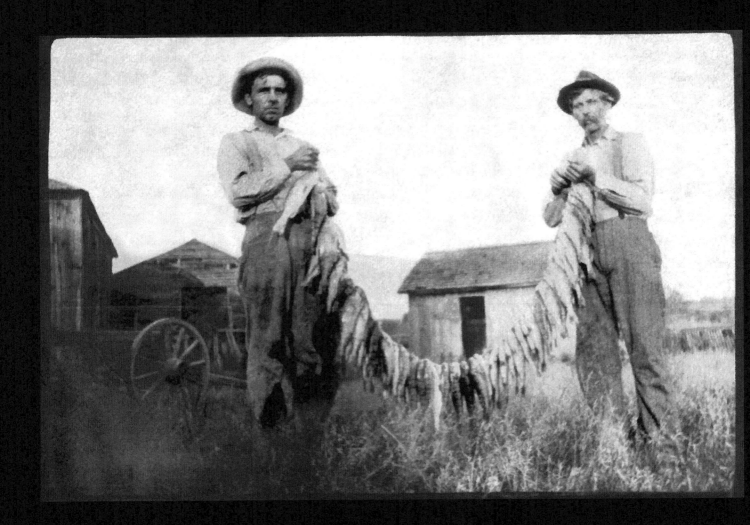

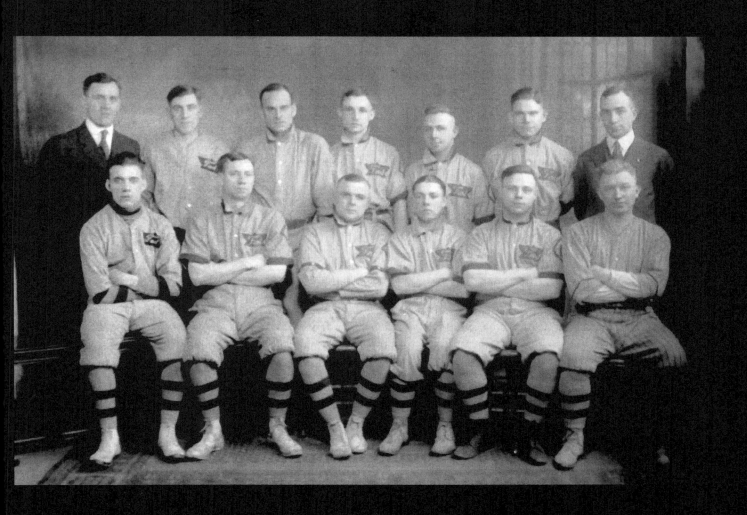

Team Ford

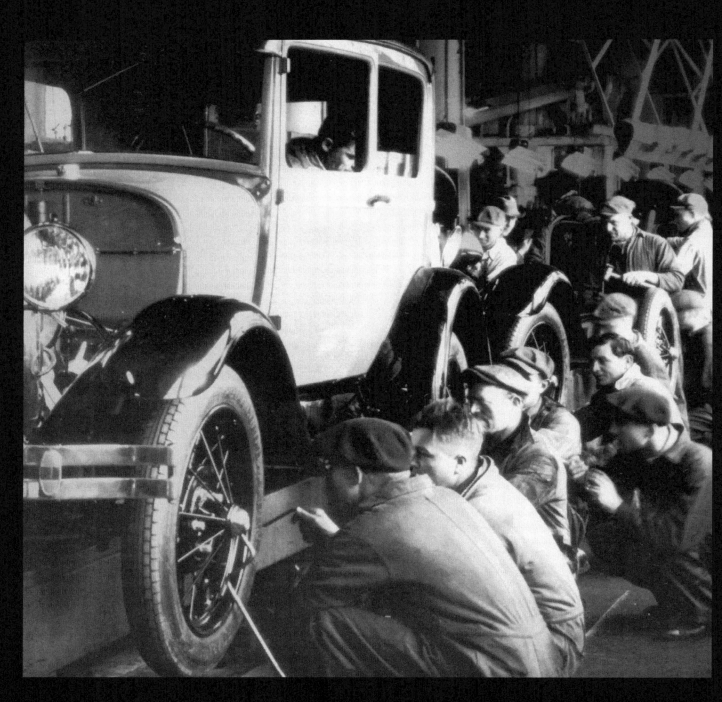
Ratchetheads, Ford Motor Company, 1910

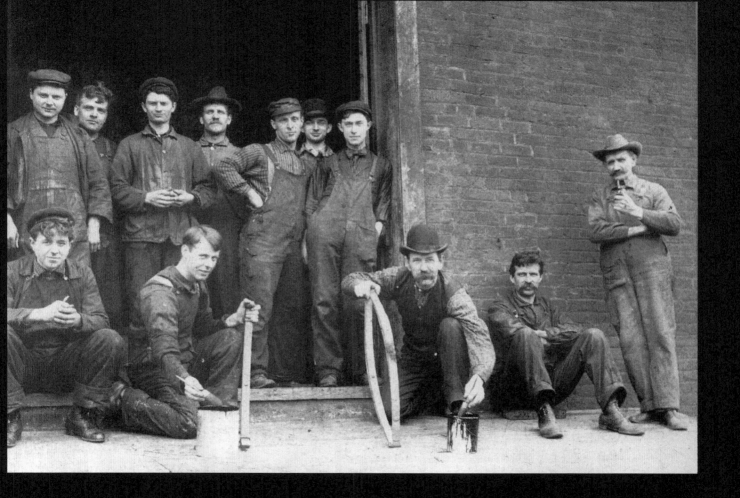

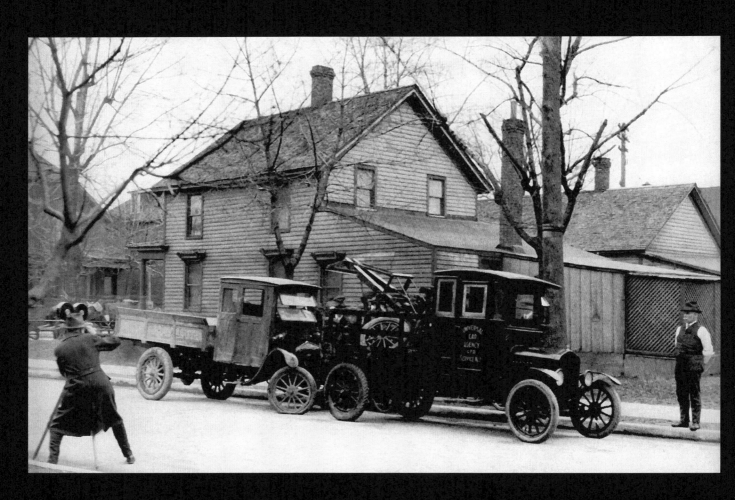

Tow Job – The Sequel

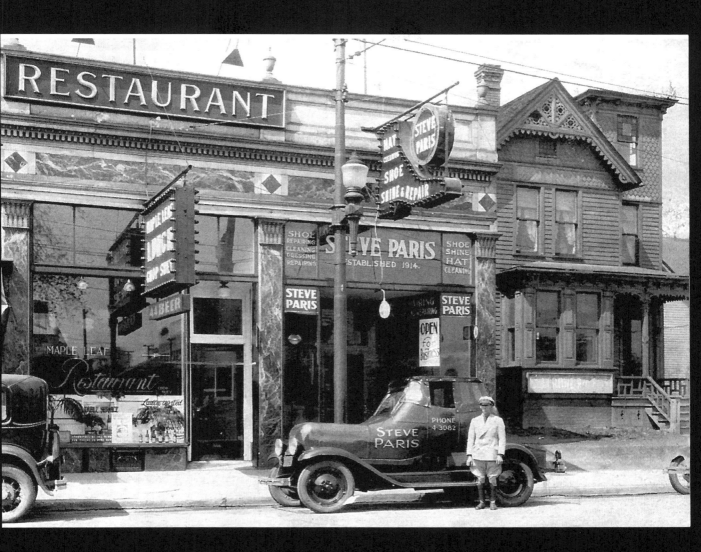

Steve Paris, est. 1914, Pelissier Street

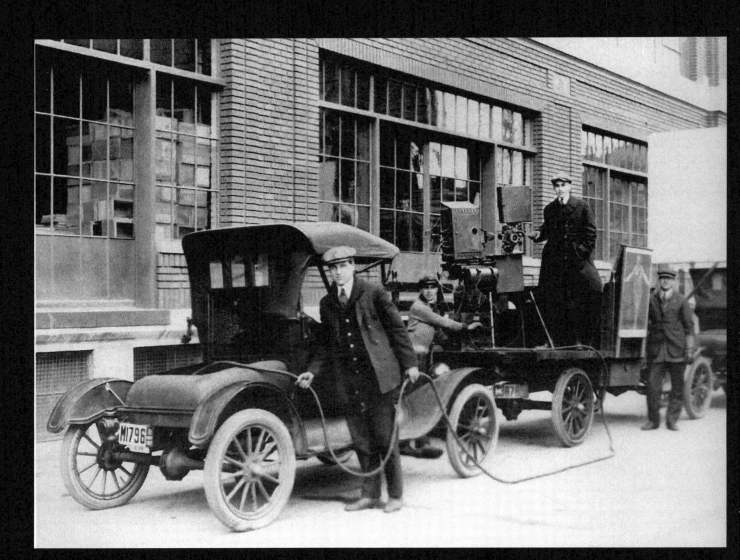

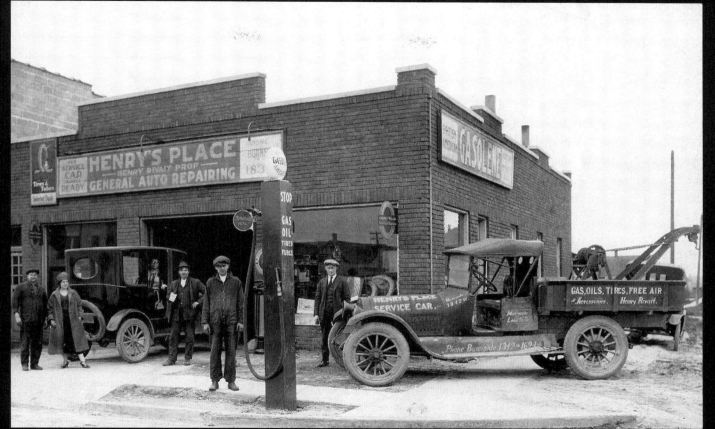

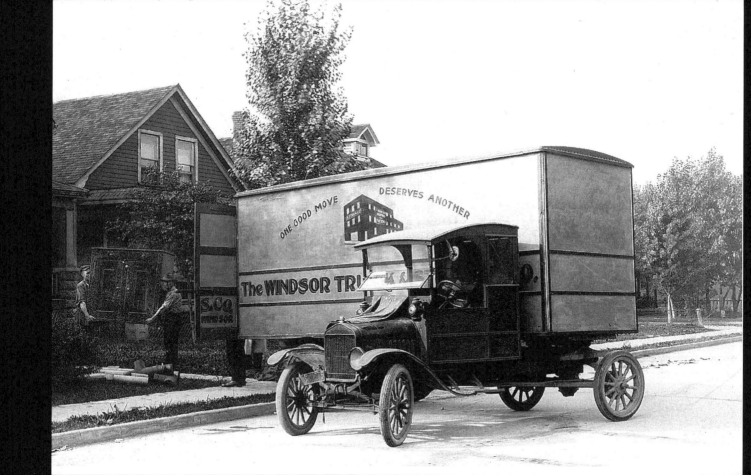

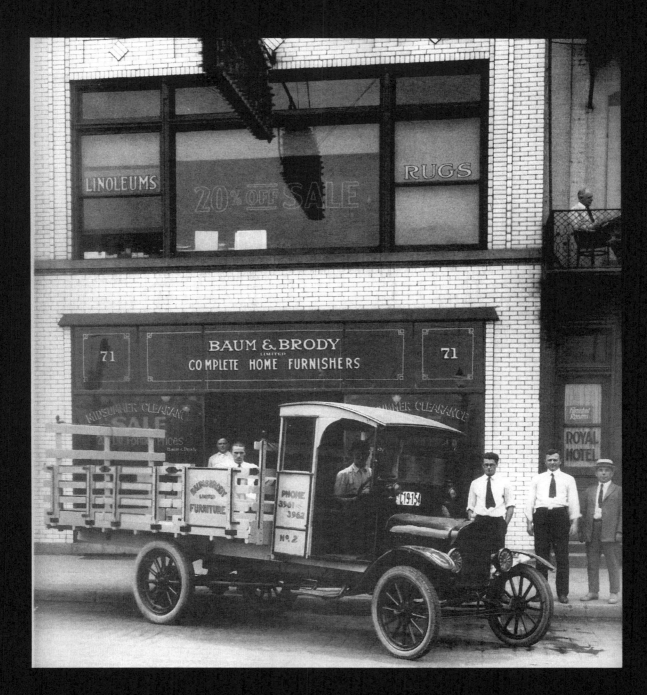

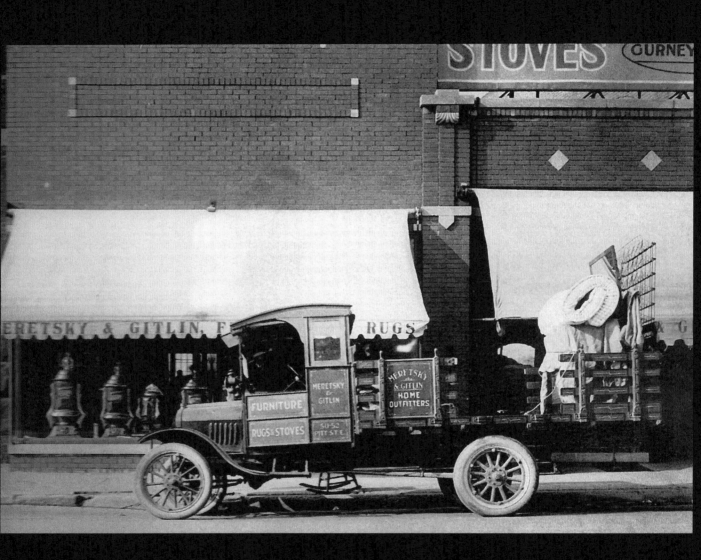

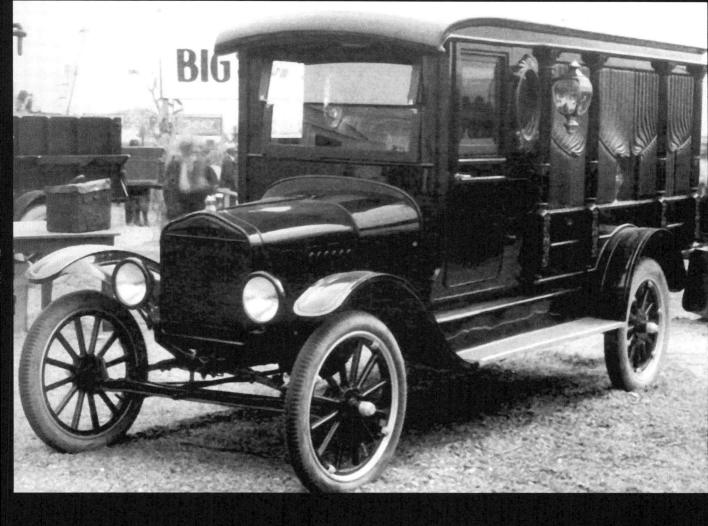

Last Ride

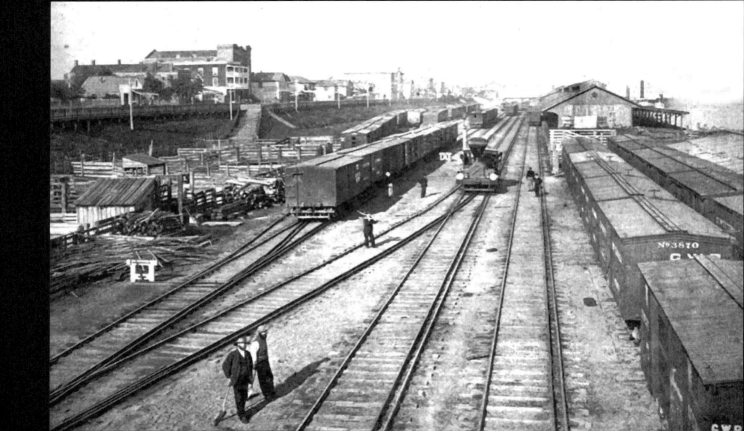

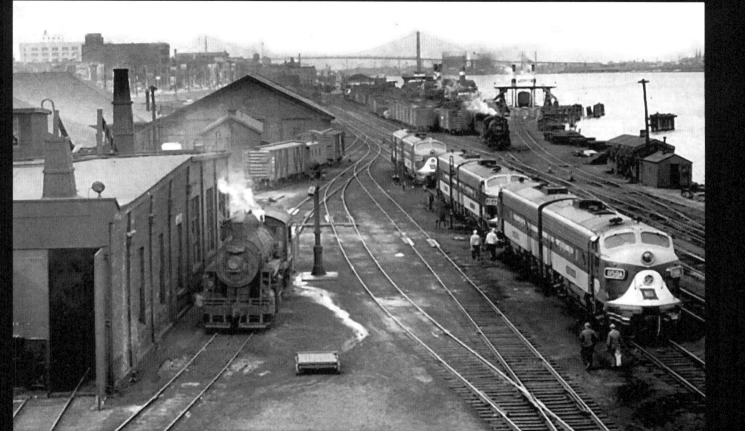

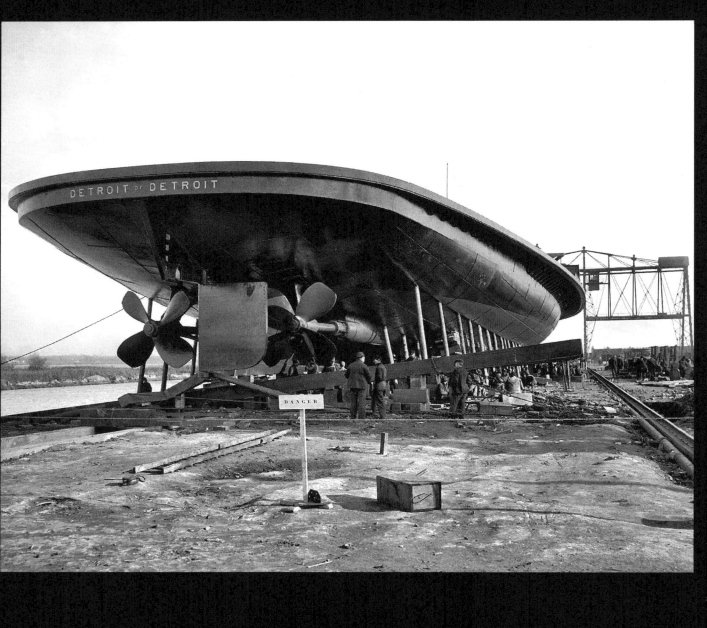

Ferry "Transfer II" Under Construction, Ecorse Michigan, 1904

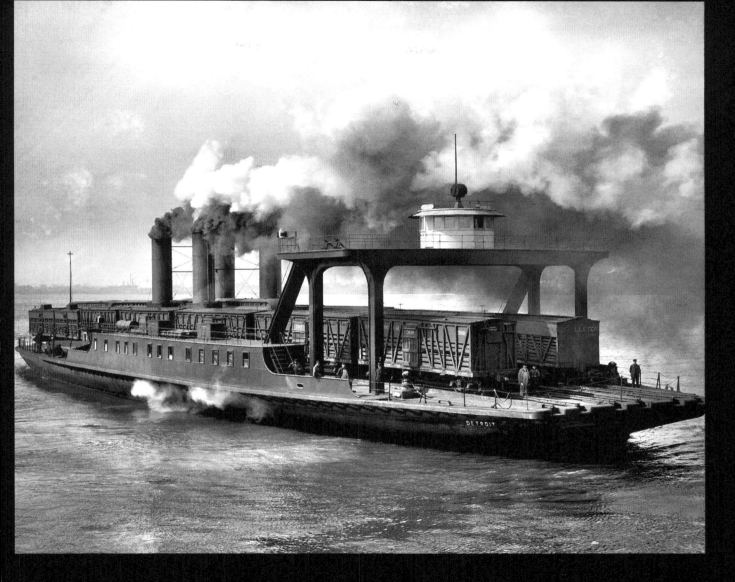

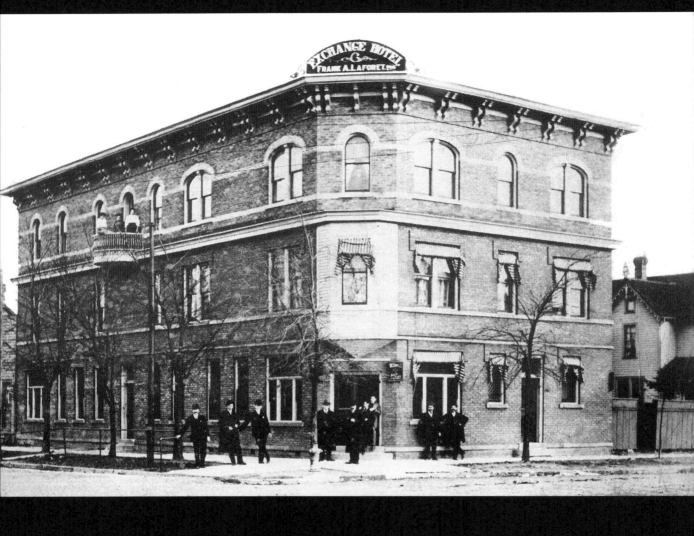

Frank LaForet's Exchange Hotel - now The Victoria Tavern

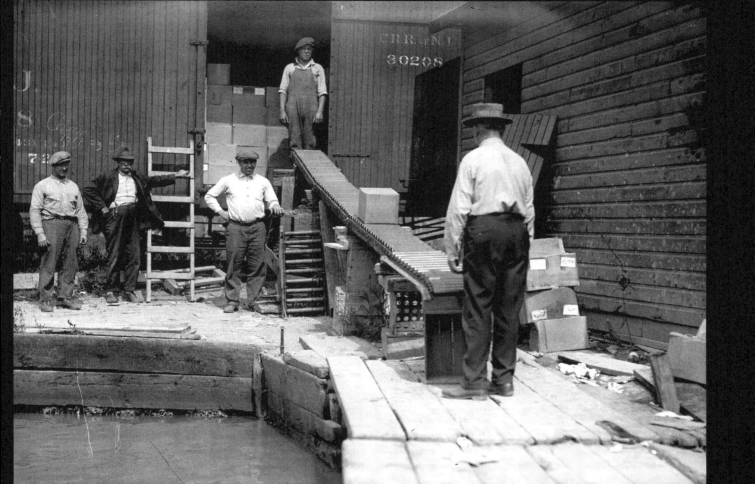

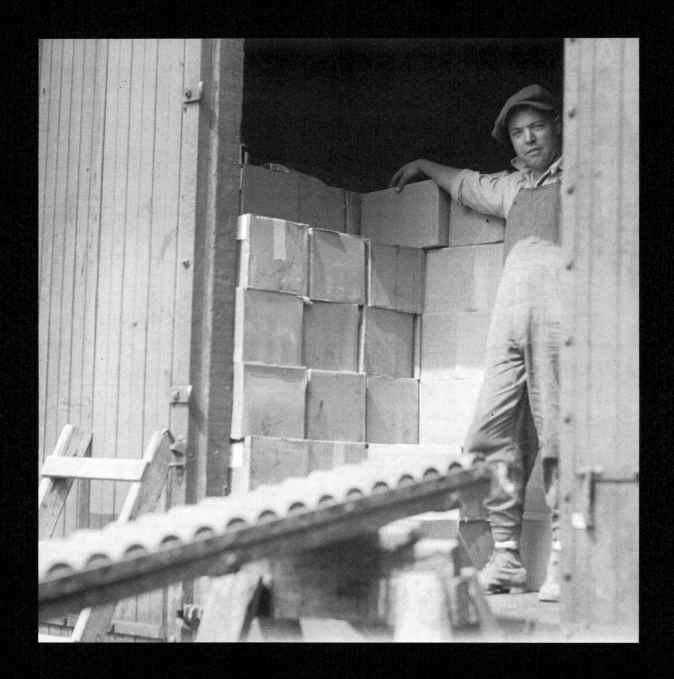

Whisky Smuggling Man

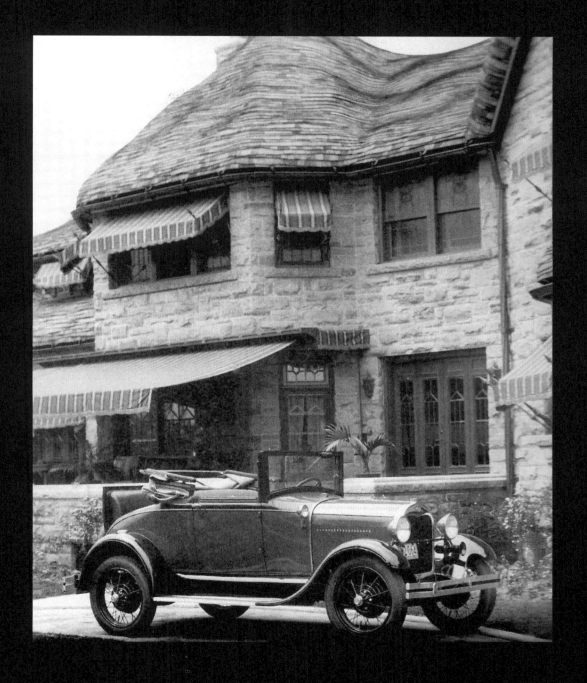

Spoils of the Whisky Trade, Low-Martin House

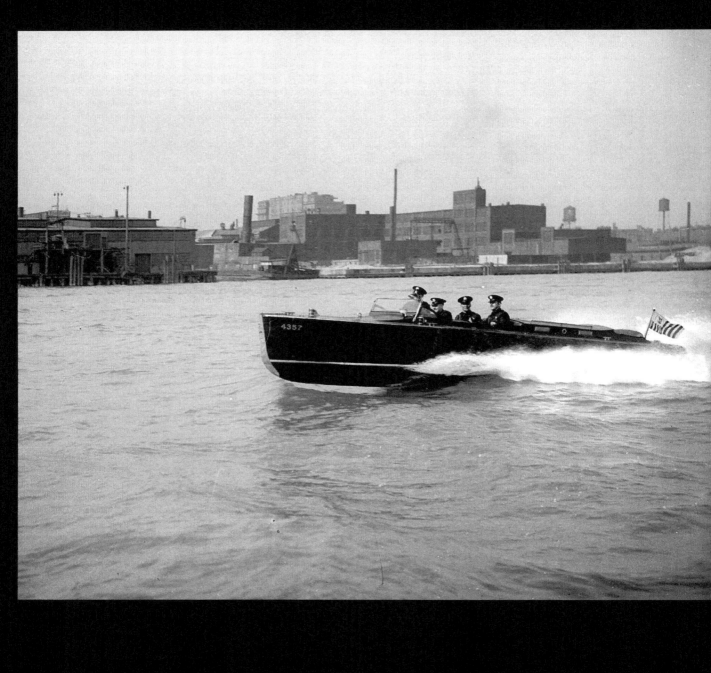
Chasing Smugglers

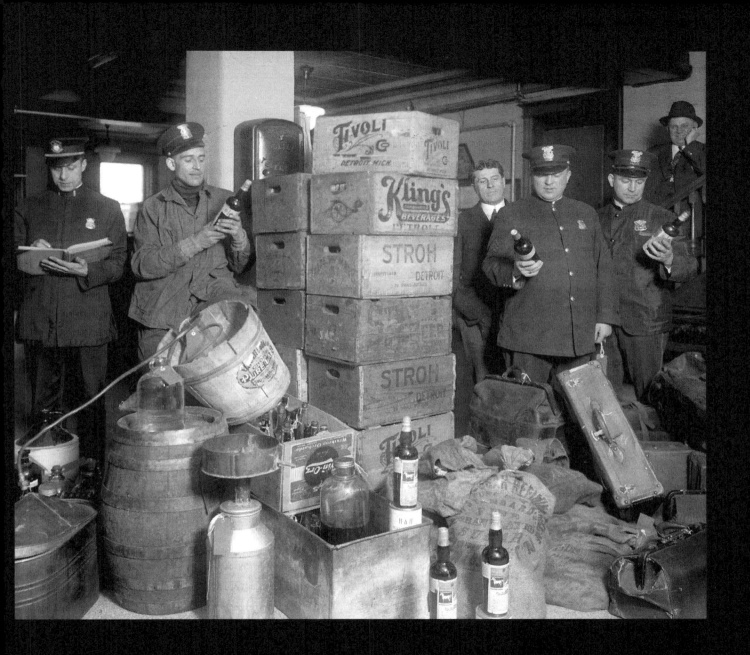

THE BIG SCORE

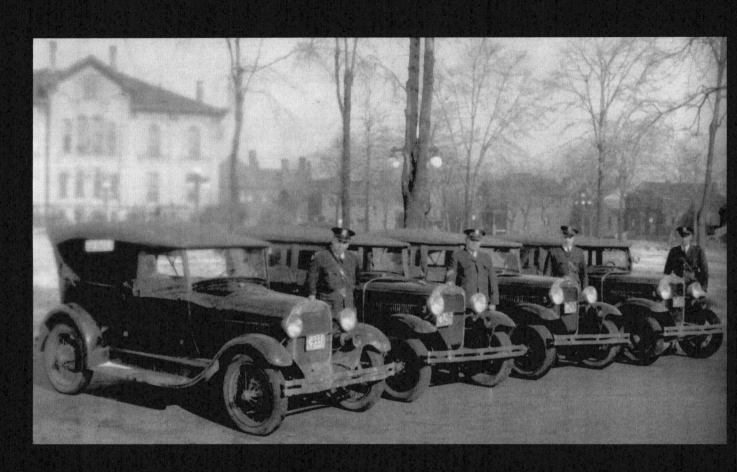

The Force Be With You

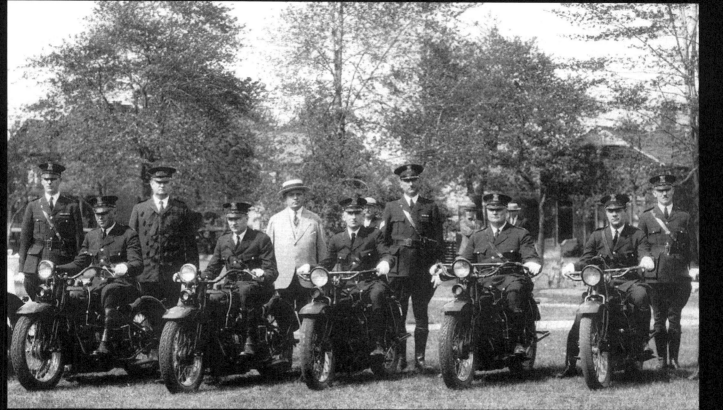

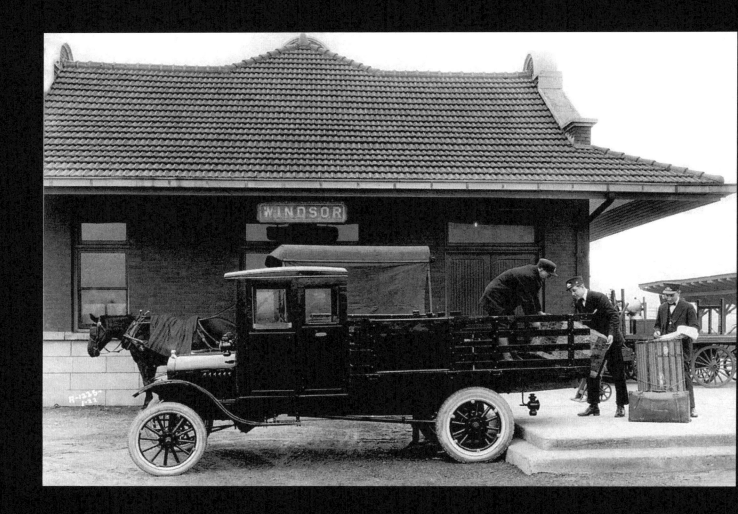

END OF AN ERA

COOLING OFF IN THE DETROIT RIVER, 1930S

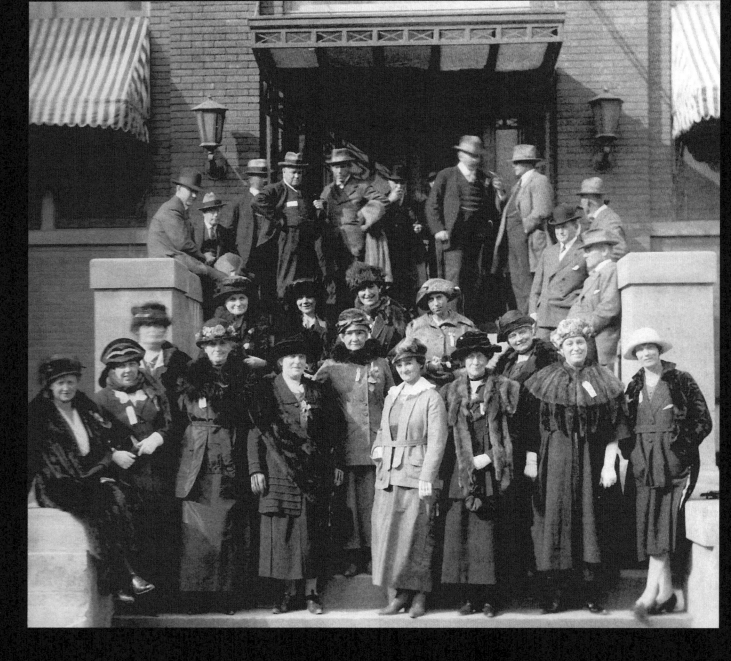

Dressed For The Occasion

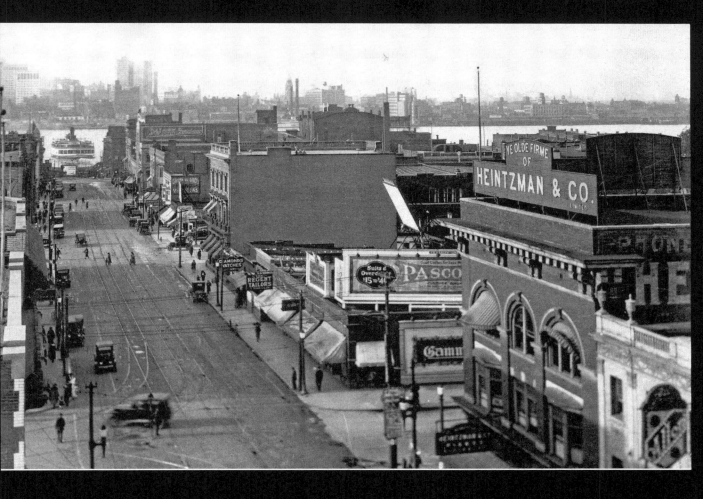

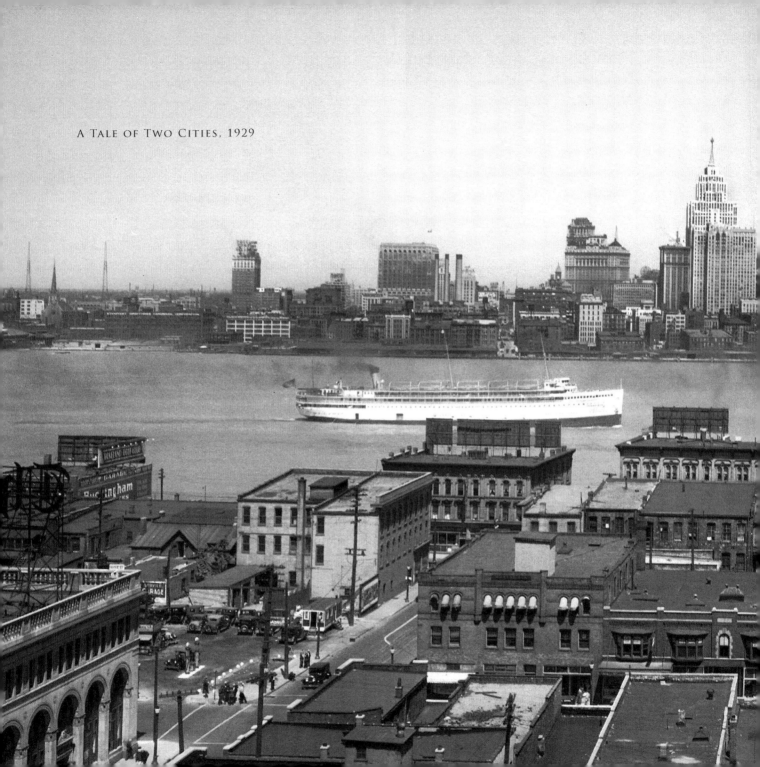

A Tale of Two Cities, 1929

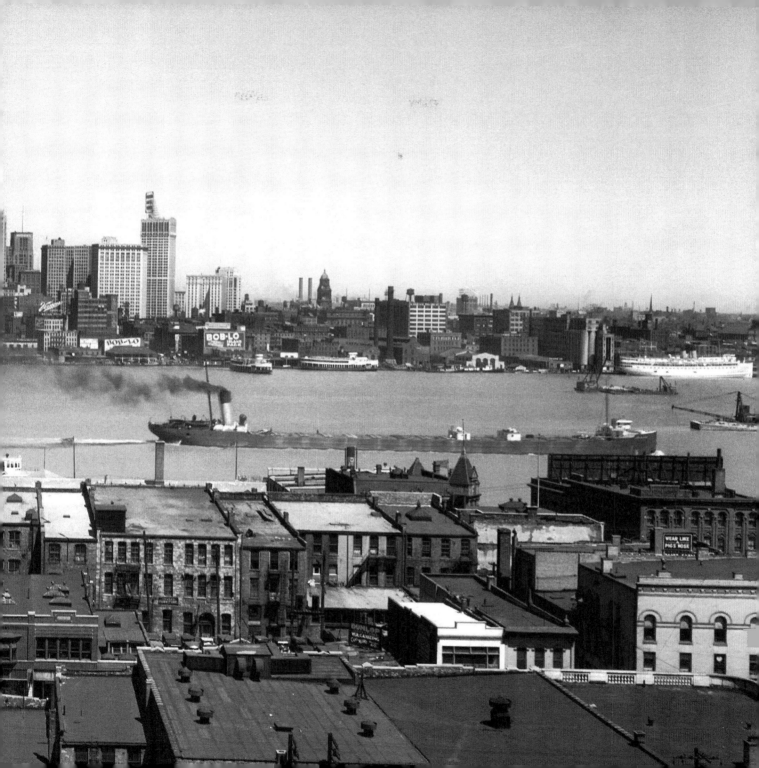

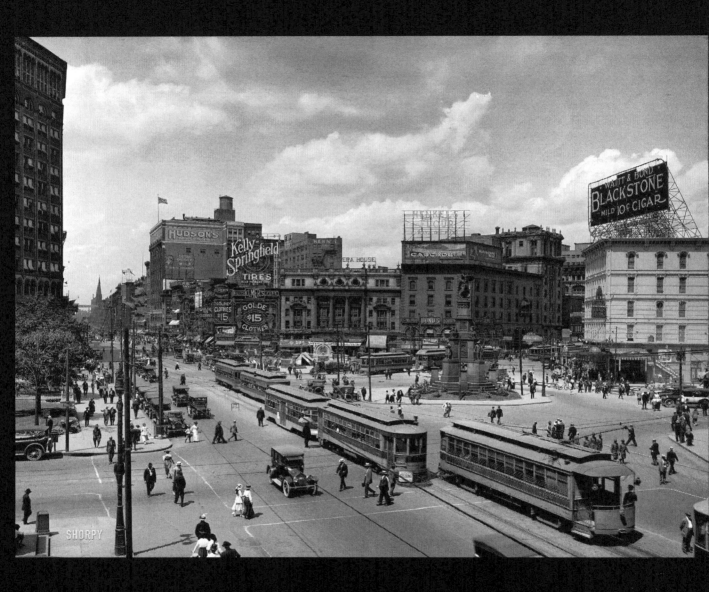

Campus Martius, Detroit, 1915

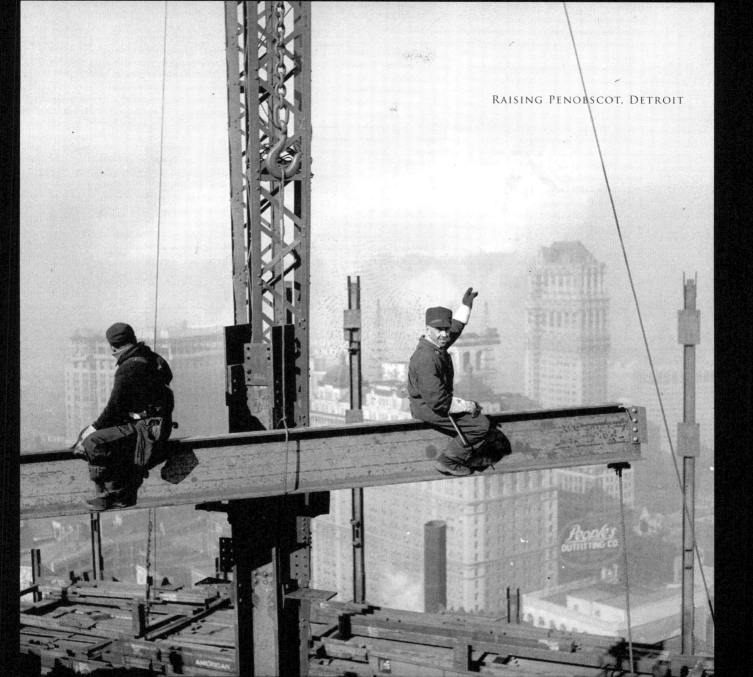
Raising Penobscot, Detroit

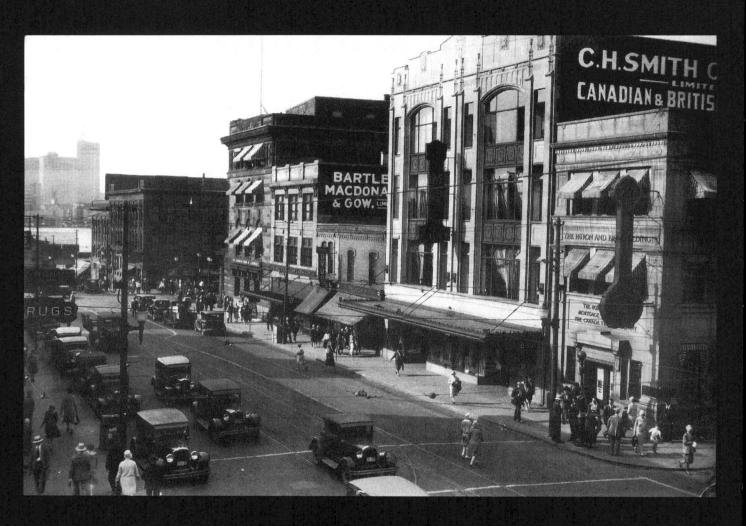

Retail Giants

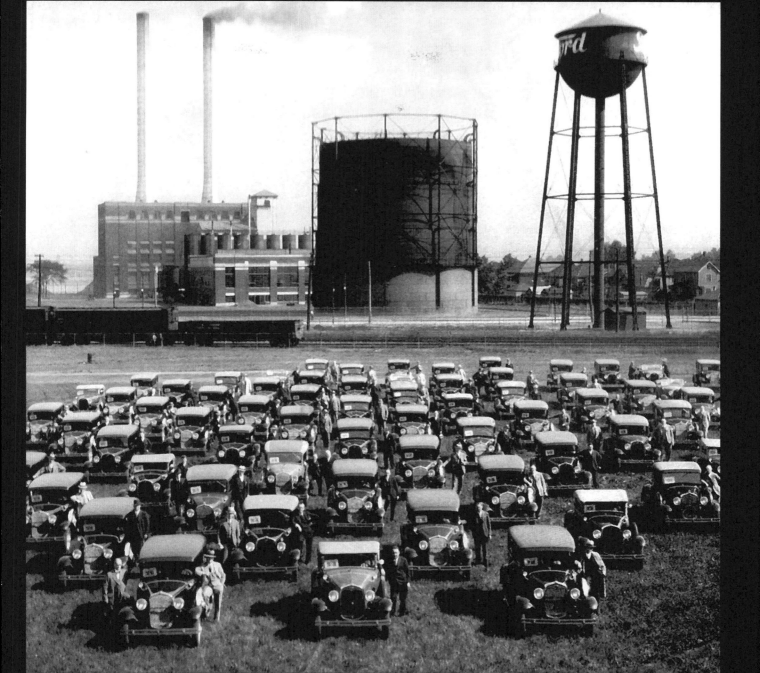

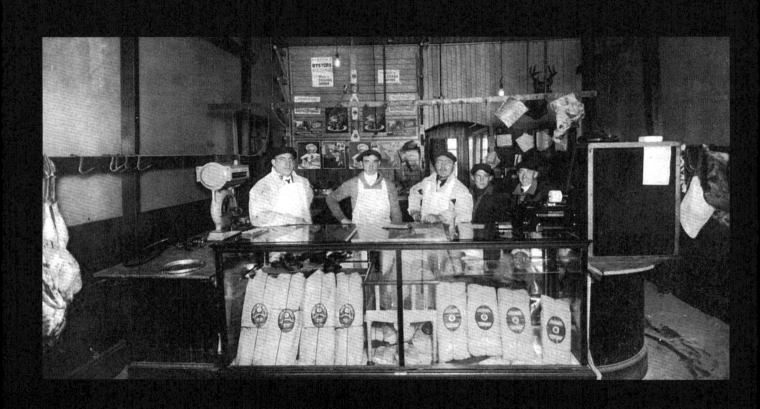

Johnson Meat Market, Walkerville, 1920s

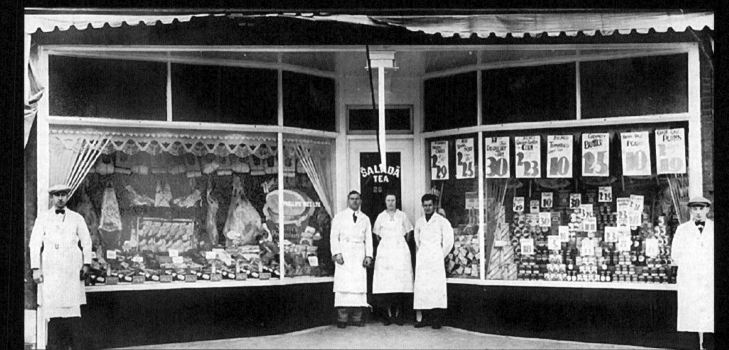

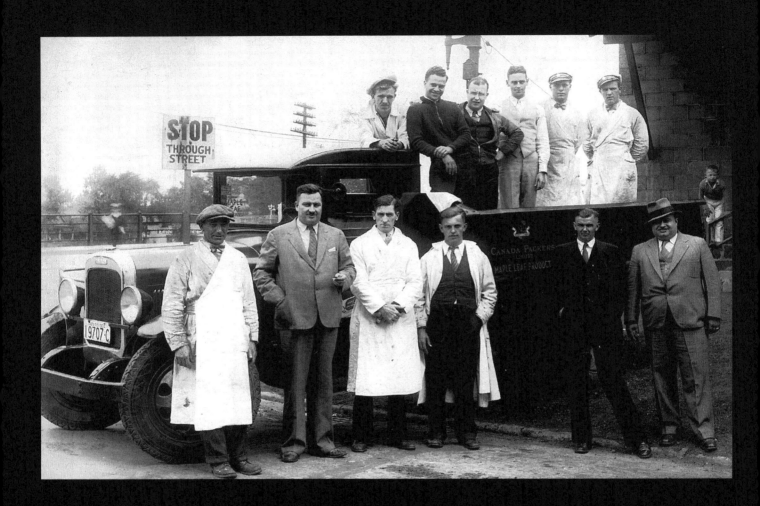

Canada Meat Packers Staff

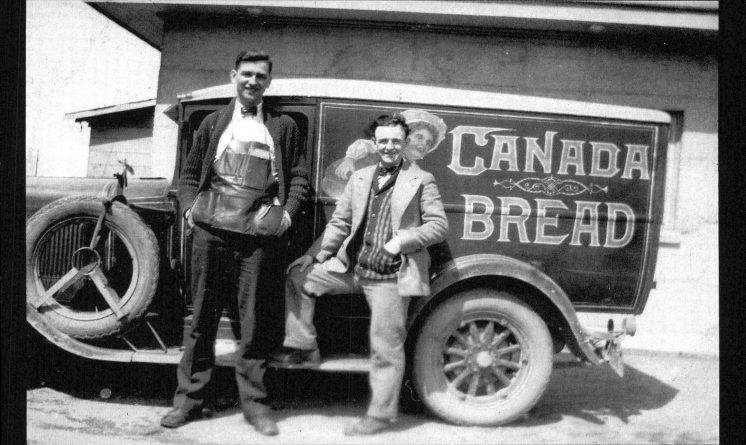

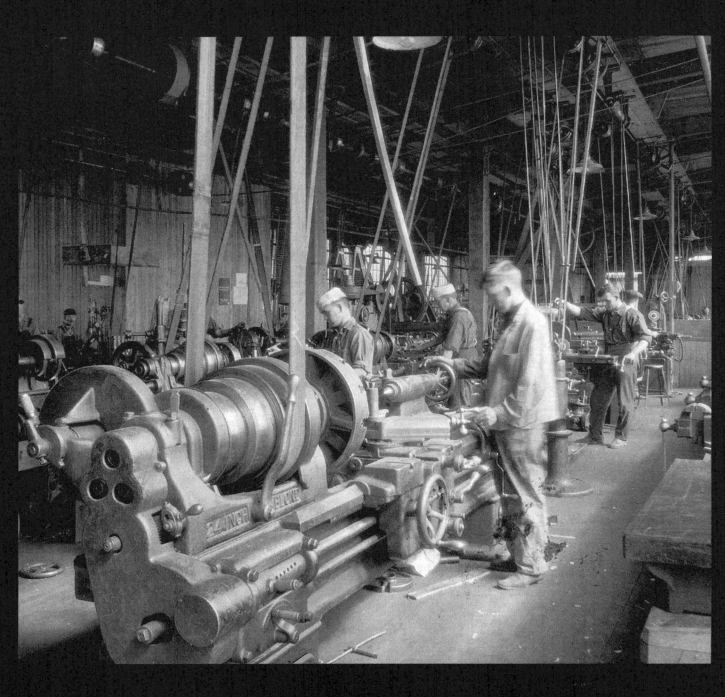
Windsor Tool & Die, 1930s

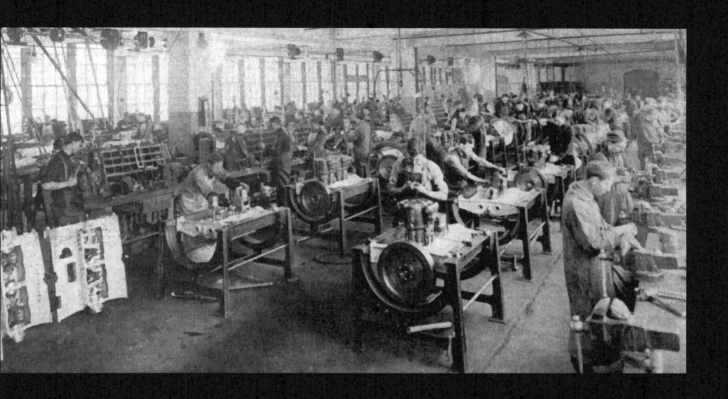

Early Tool & Die Shop

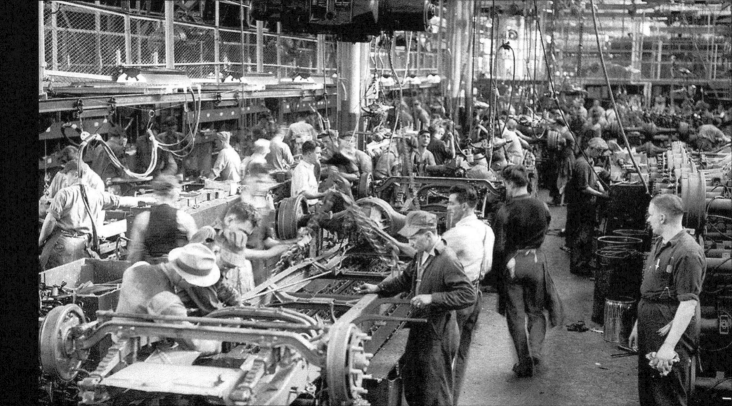

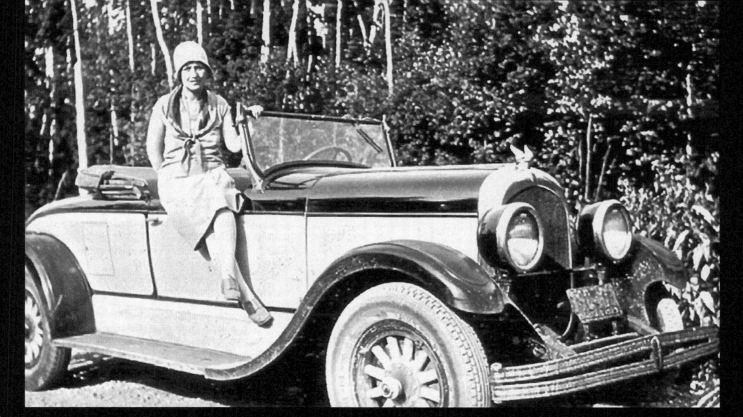

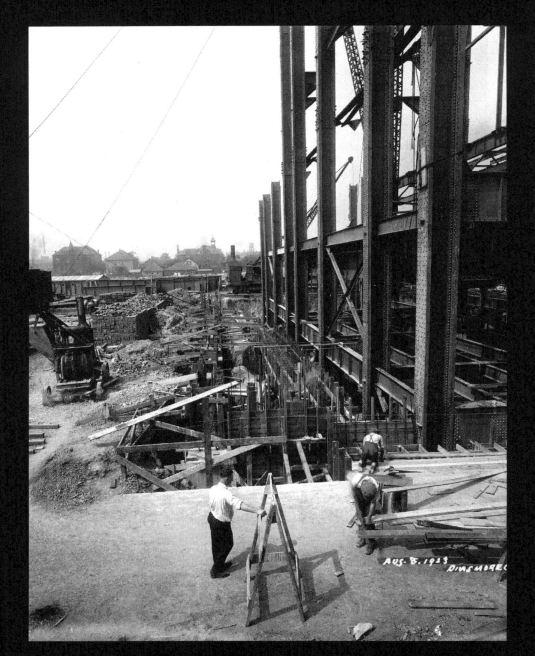

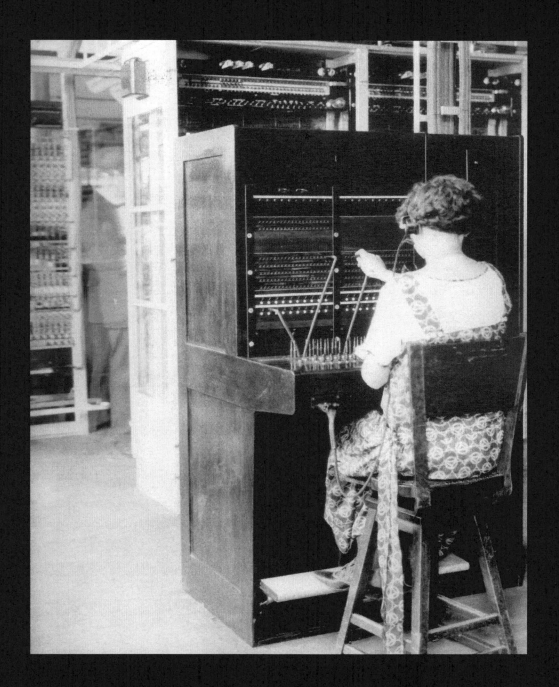

Switchboard Operator

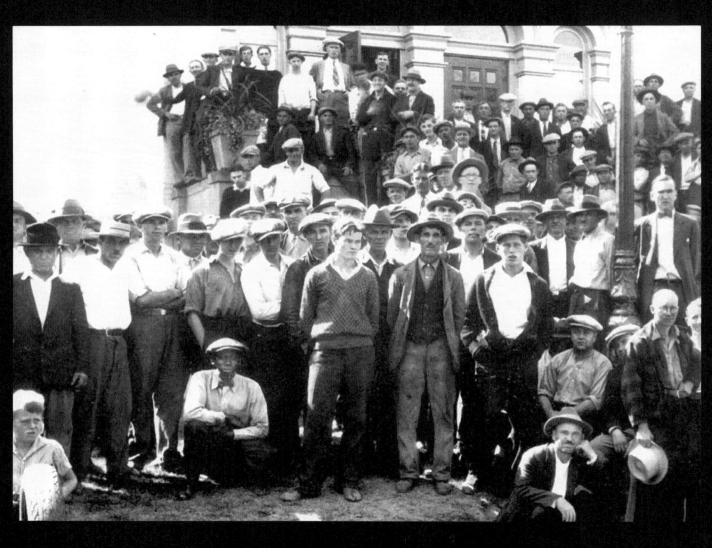

A Part of Factory District, Windsor, Canada.

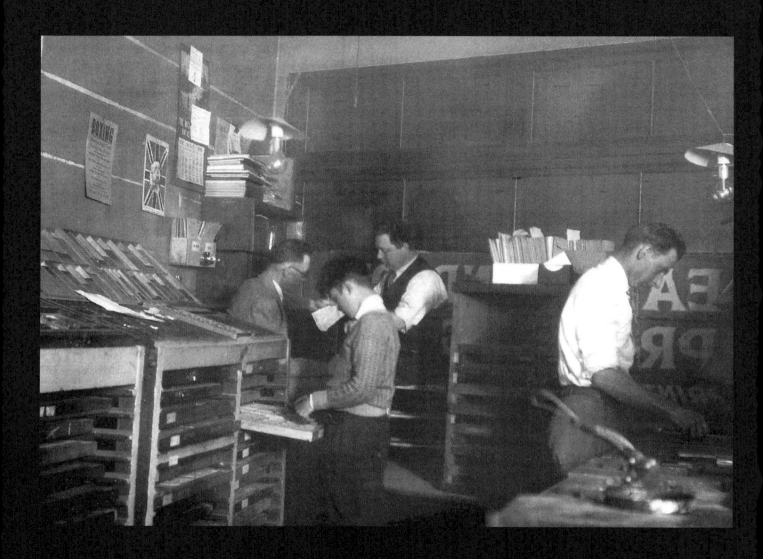

East Windsor Print Company

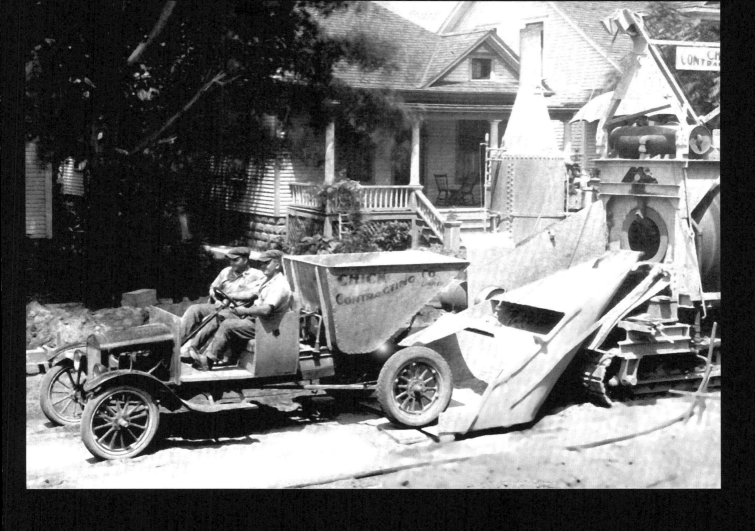

From Dirt To Concrete

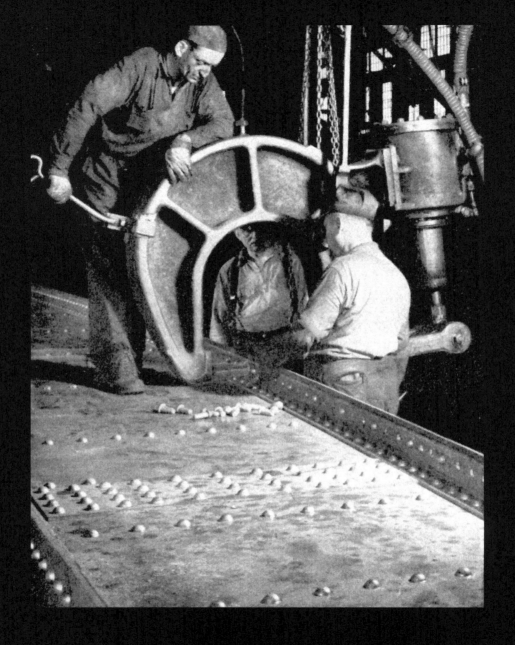
Riveters, Ambassador Bridge, 1928

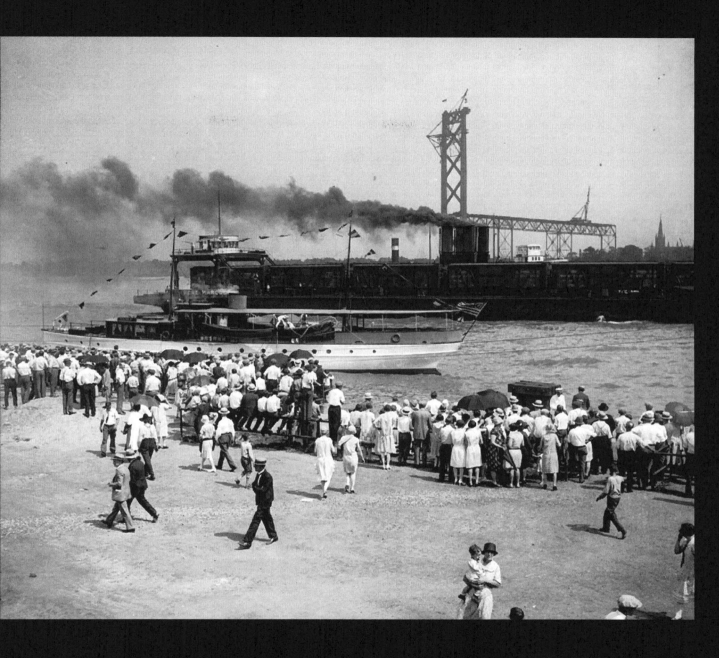

Ambassador Under Construction

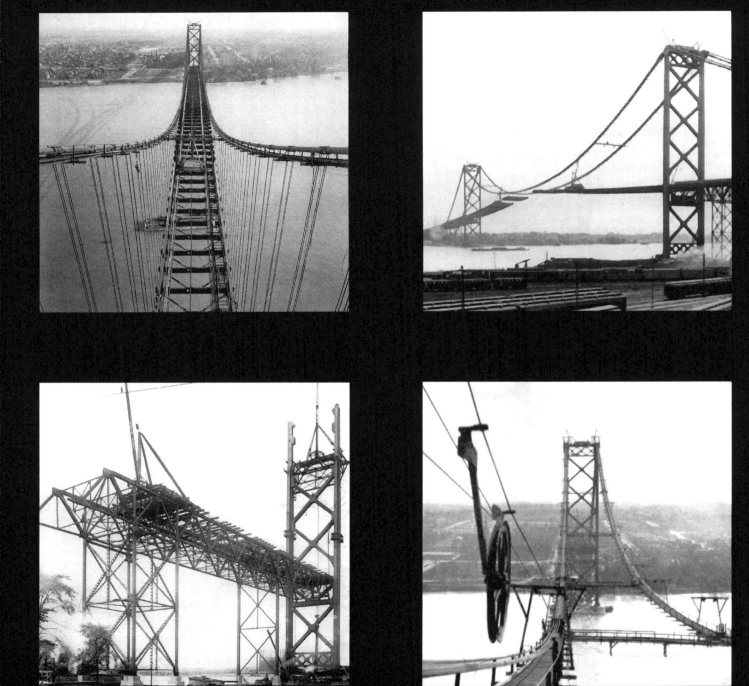

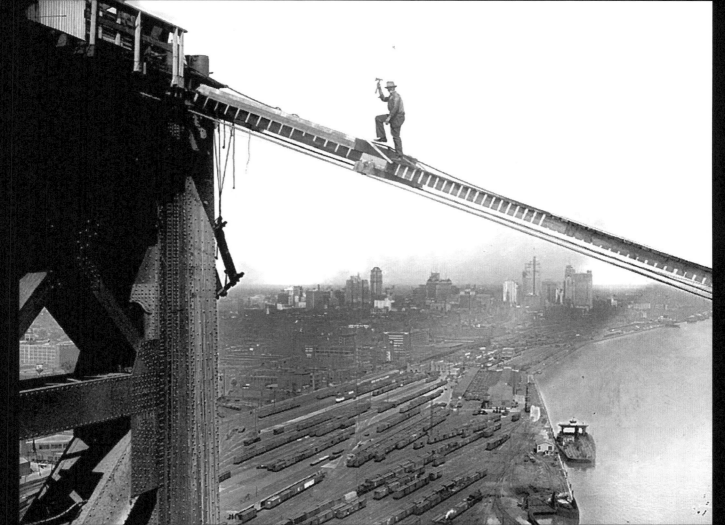

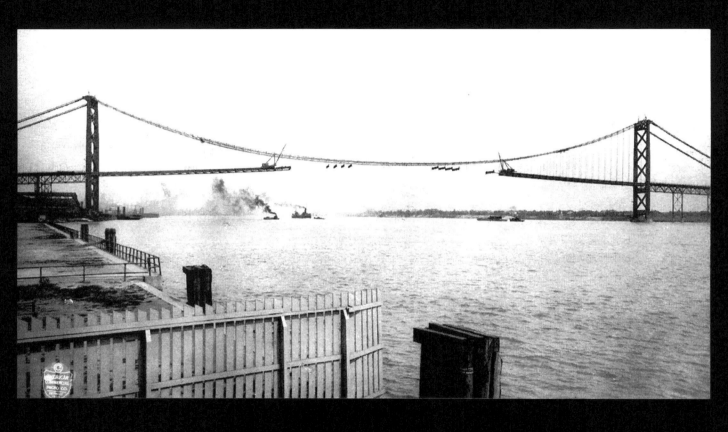

Meet You in the Middle

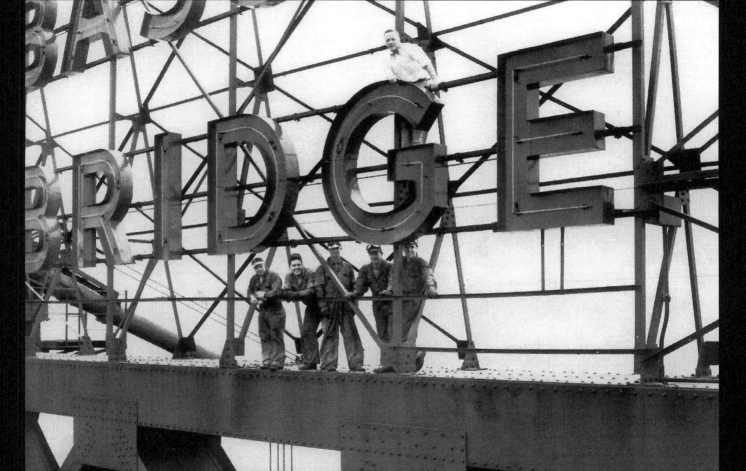

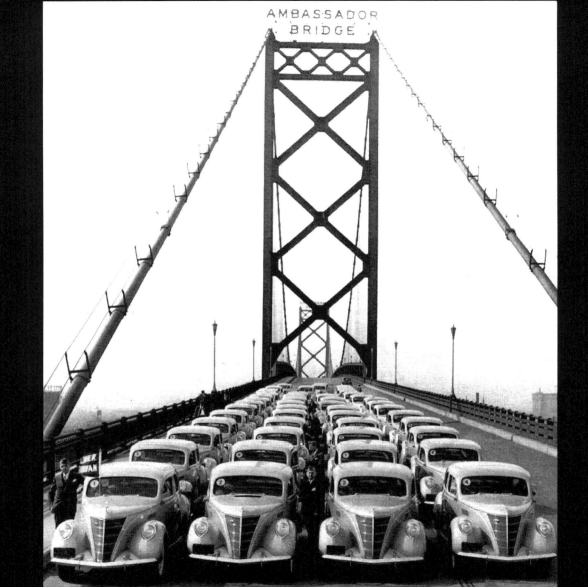

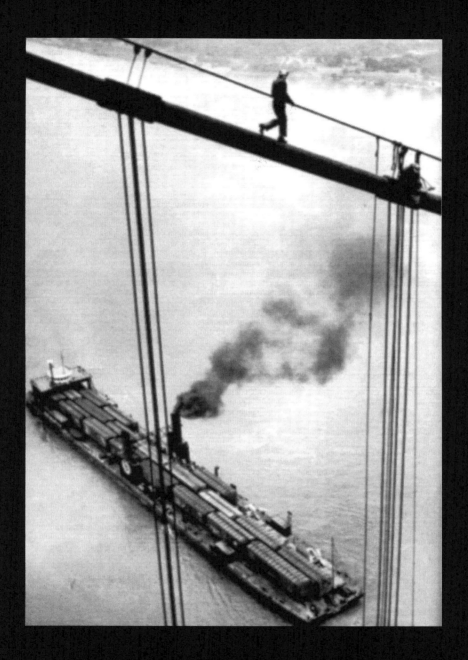

Tightwire over Ferry Lansdowne

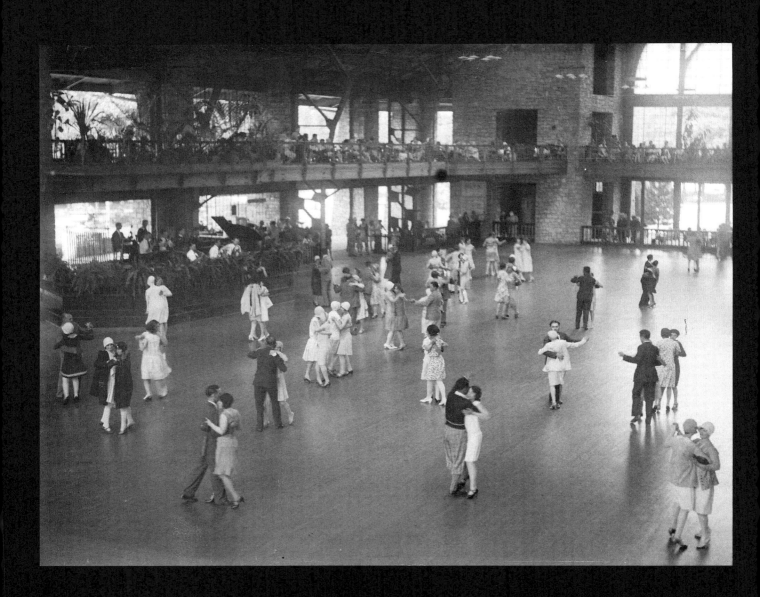
Flappers and Dancers, Boblo Island, 1920s

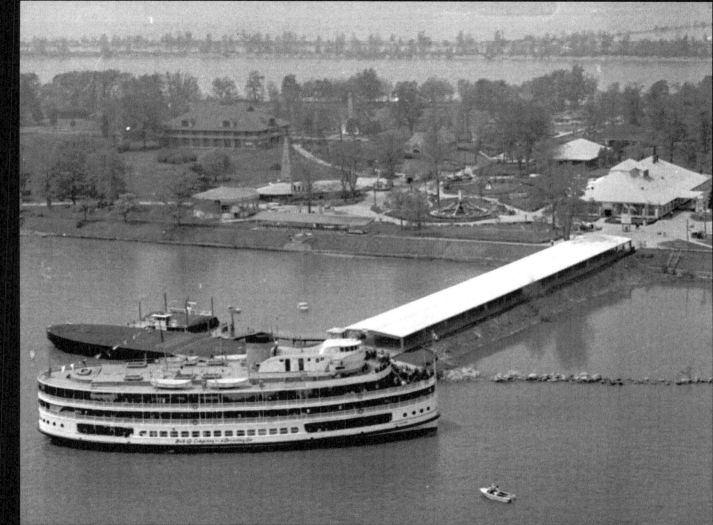

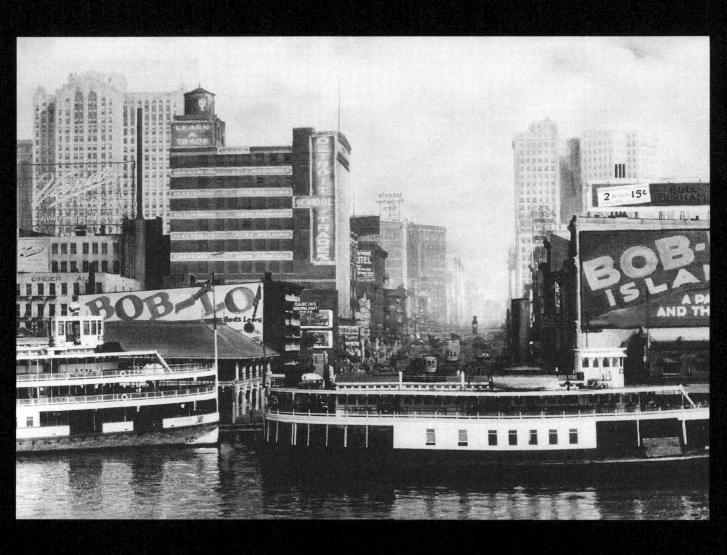

Detroit Docks, foot of Woodward, 1920s

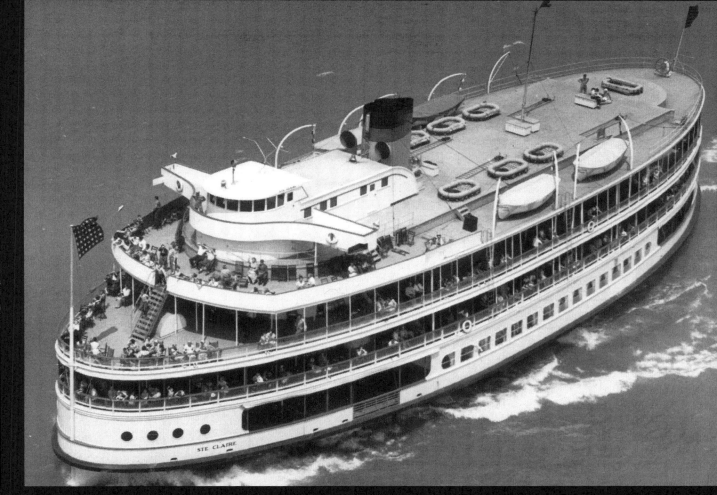

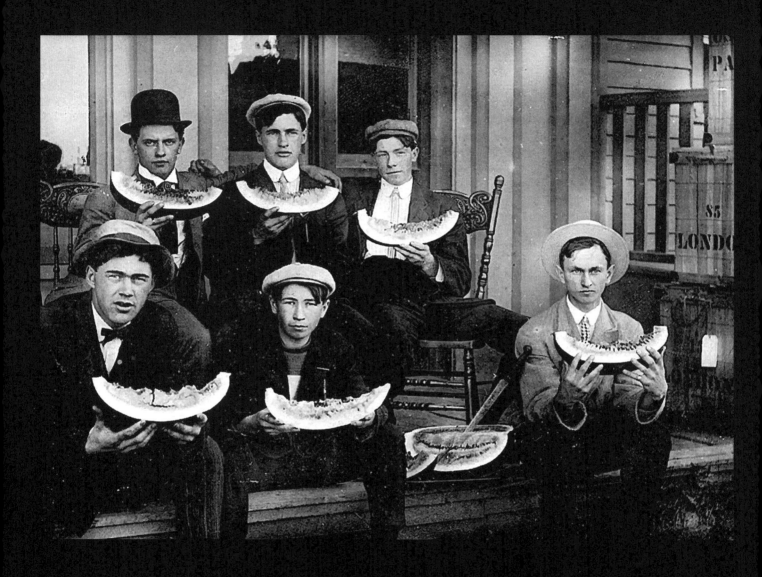

Watermelon Boys

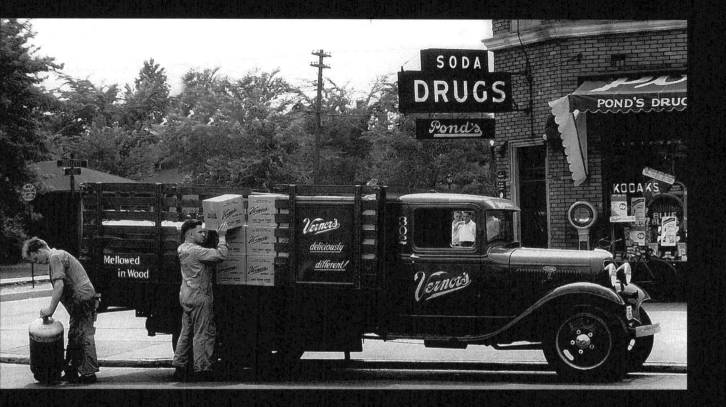

Mellowed in Wood

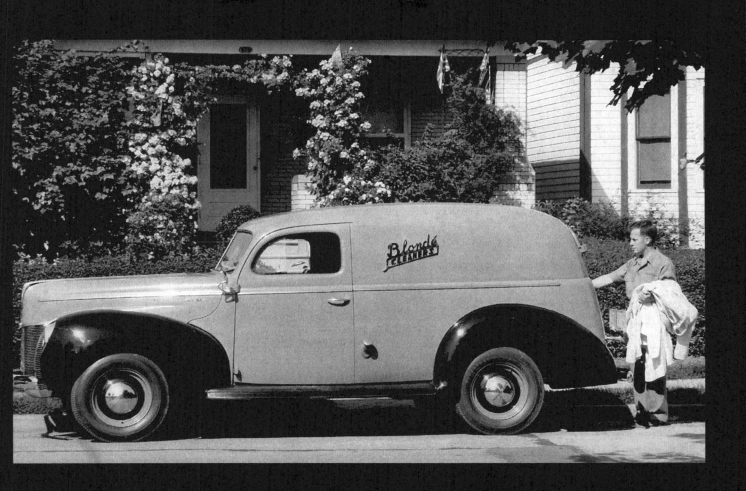

CLEAN TEAM

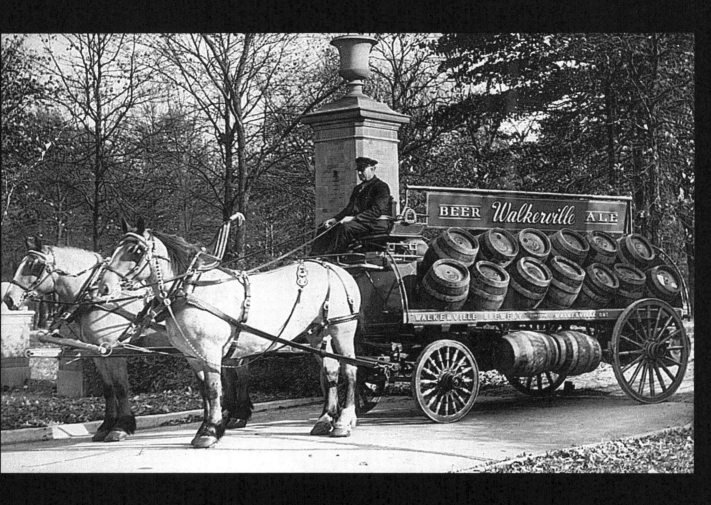
Walkerville Brewery Teamster at Memorial Park Gates, 1930s

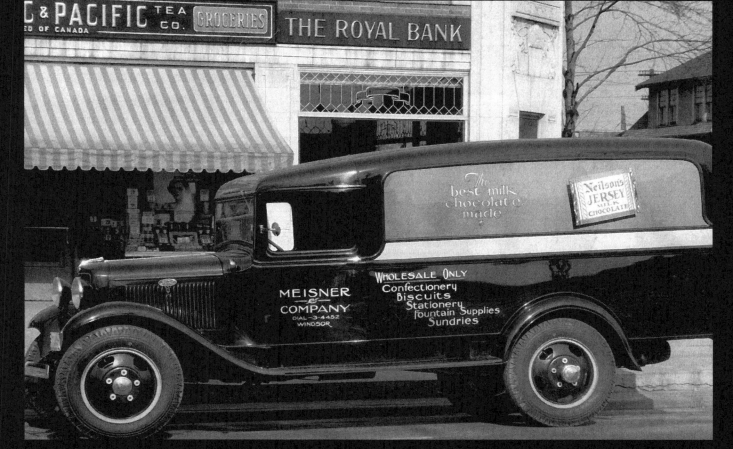

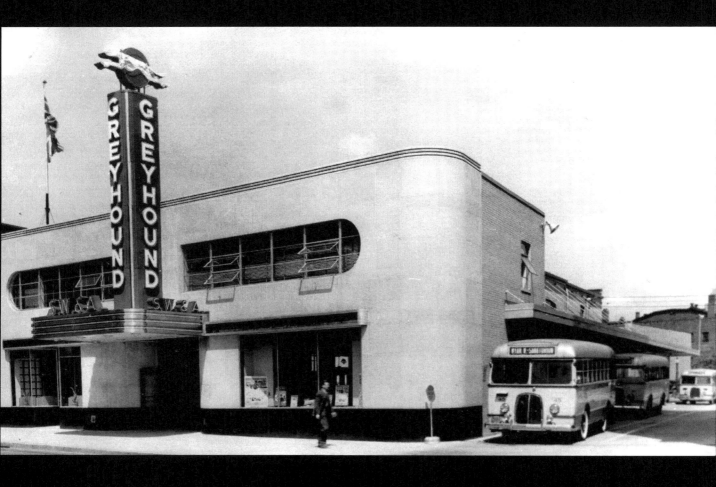
SW&A Terminal, University Avenue

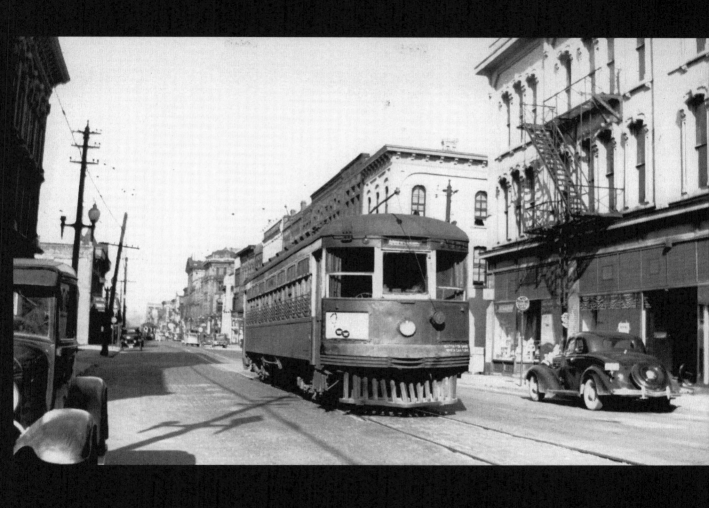

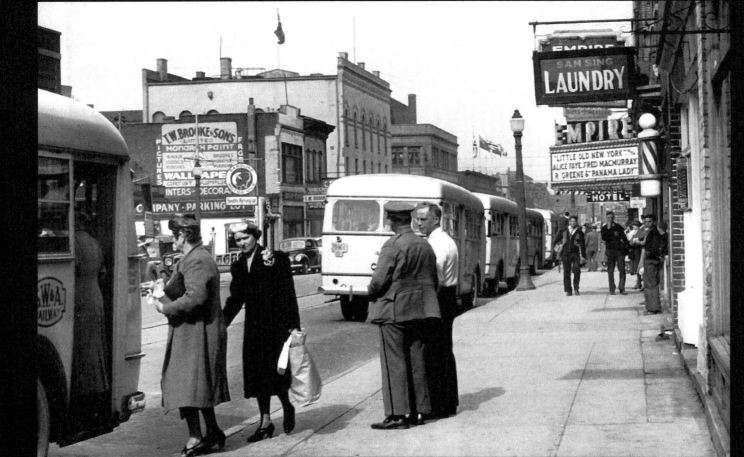

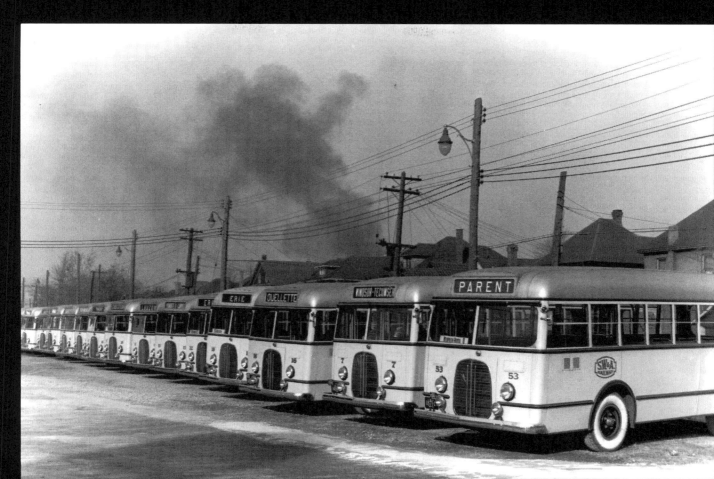

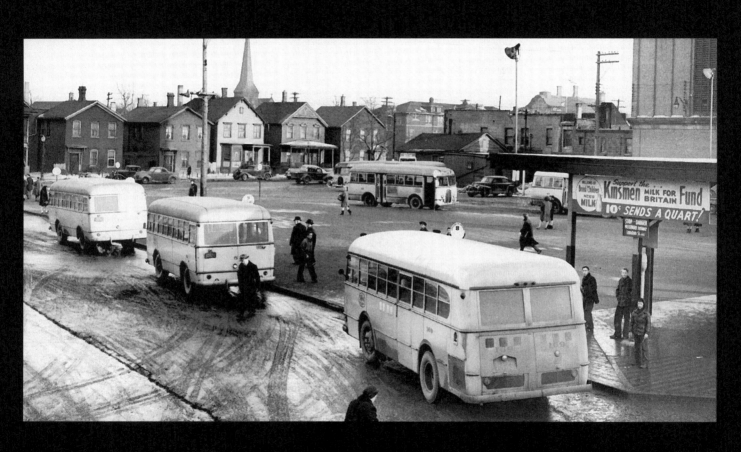

Downtown Bus Depot, Chatham Street, 1940s

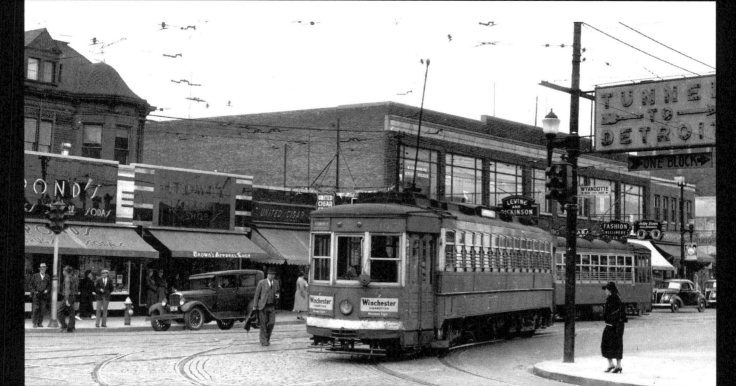

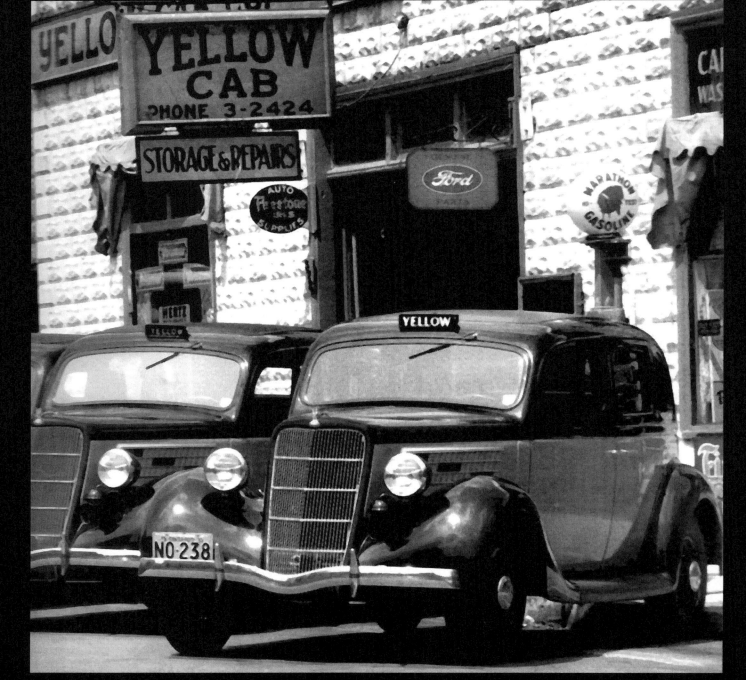

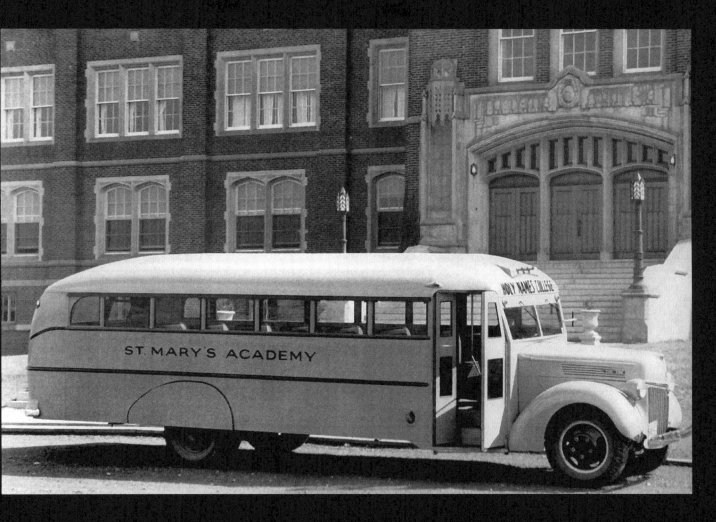

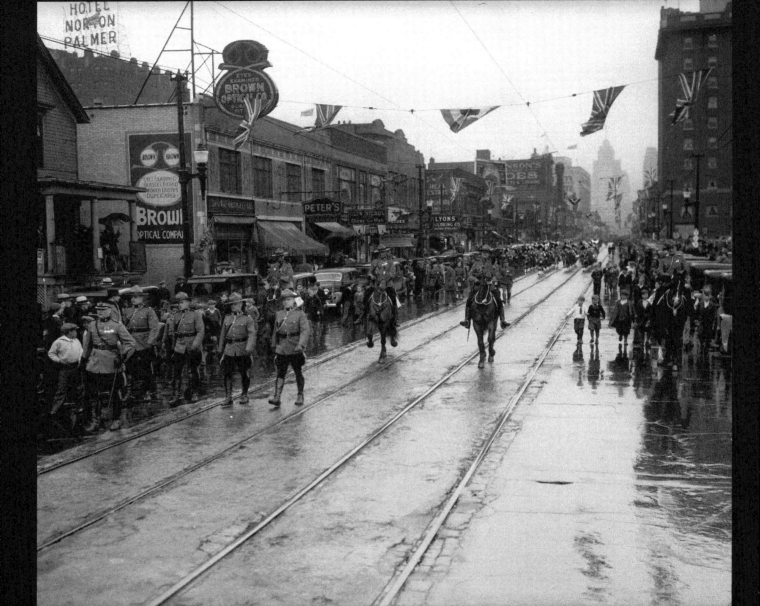

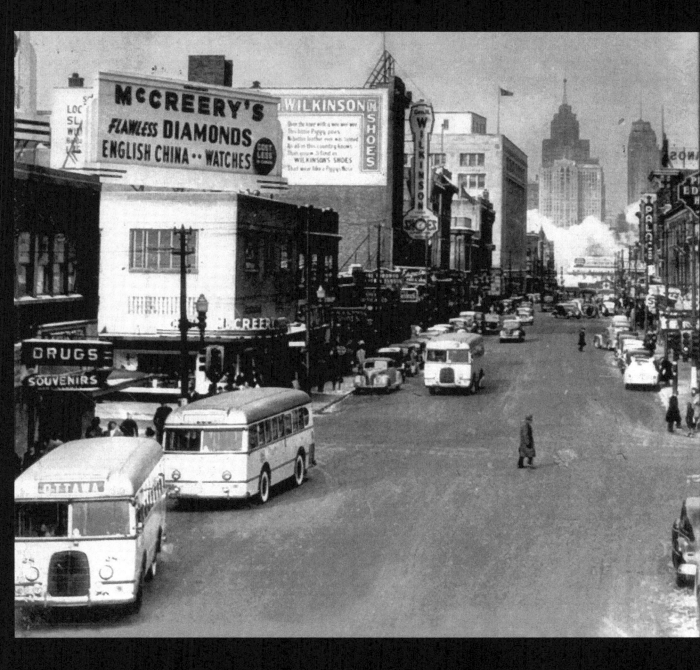

End of the Streetcar Era, 1940

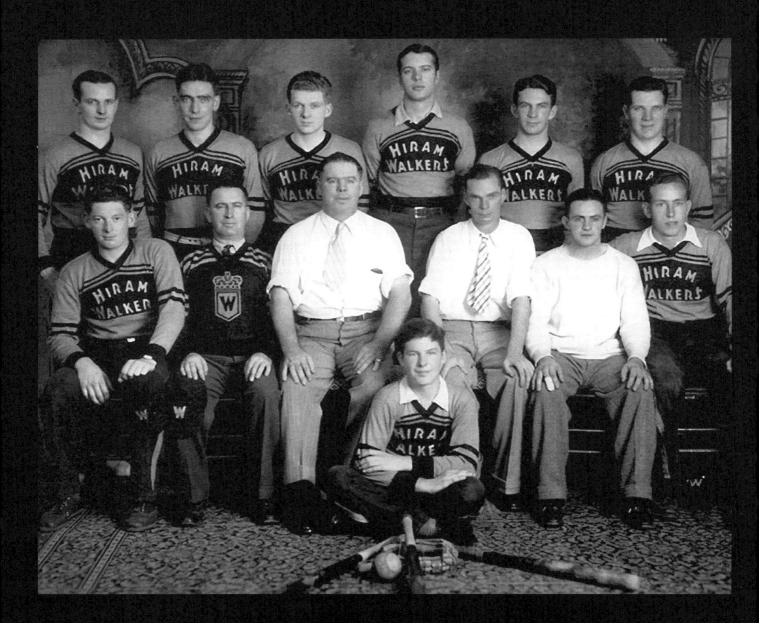

Team CC

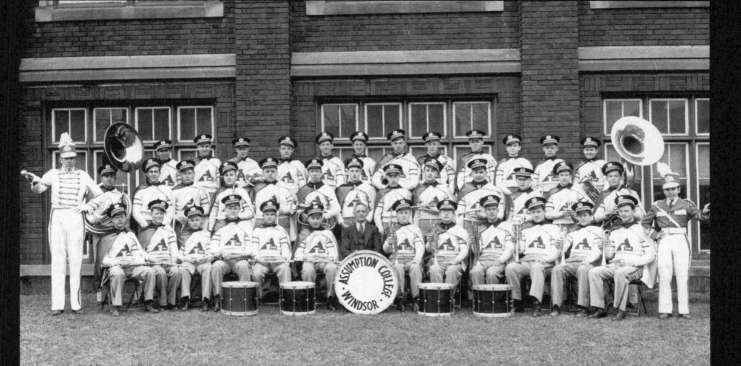

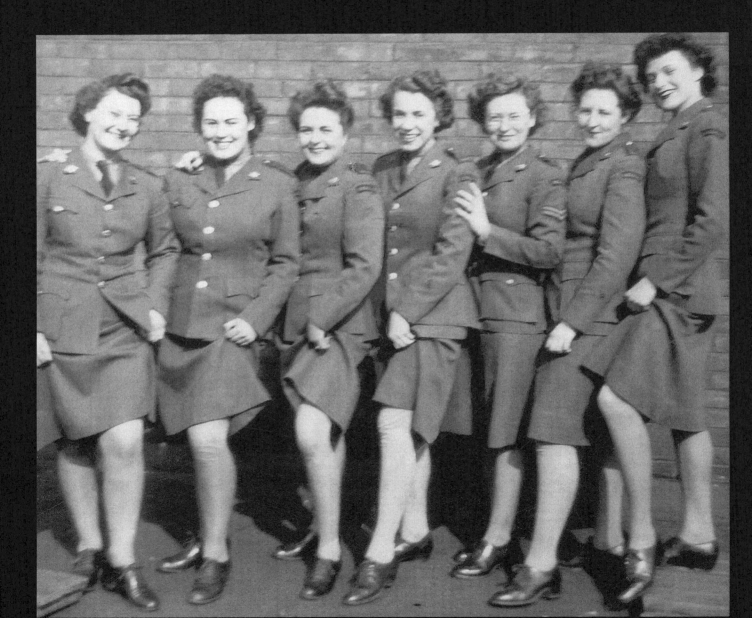

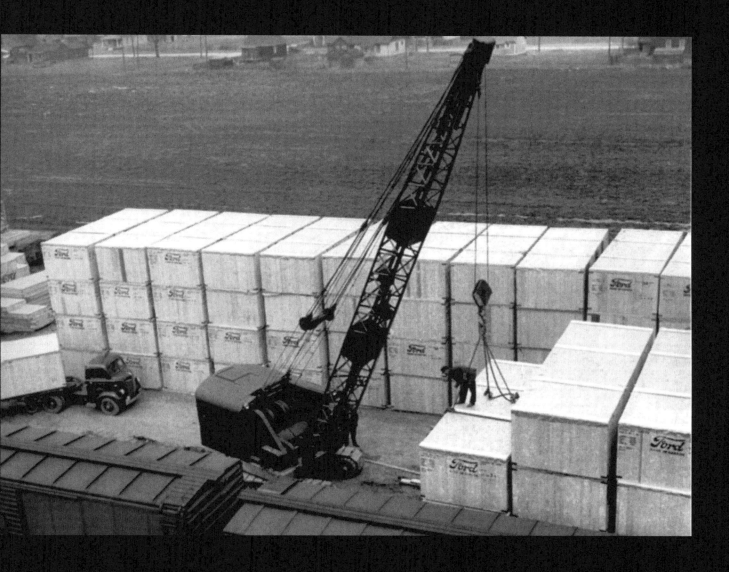

Made in Windsor Ford Jeeps Packed Off To War

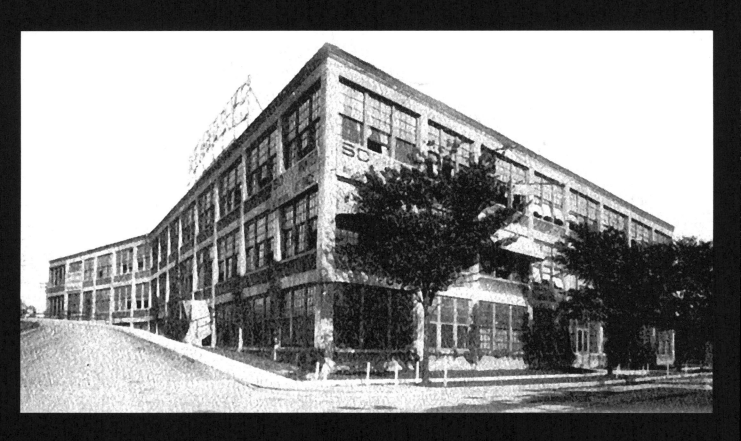

The Peabody Building, Riverside at Chilver

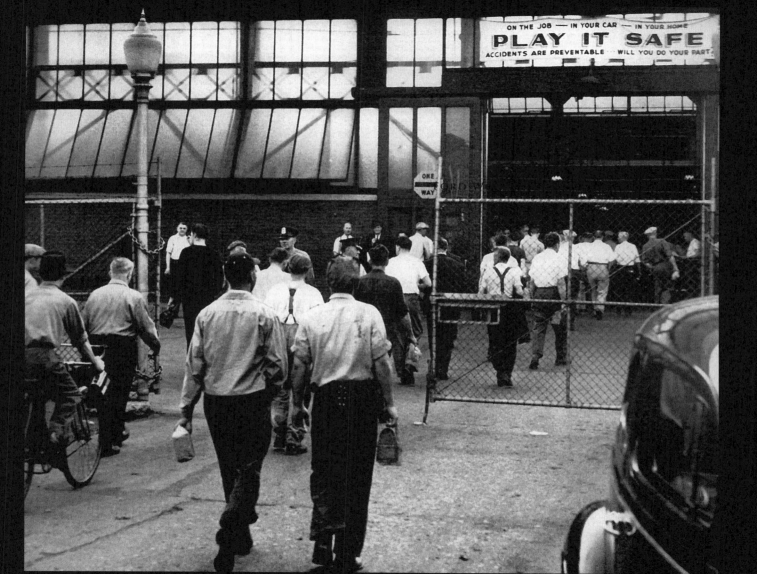

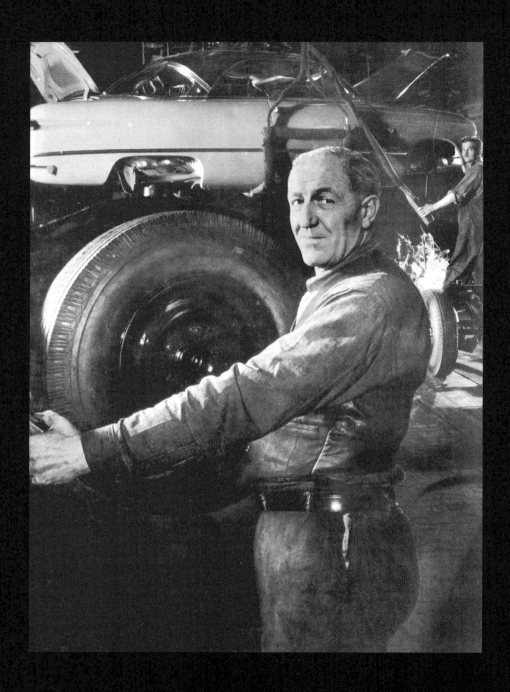

Portrait of a Ford Worker

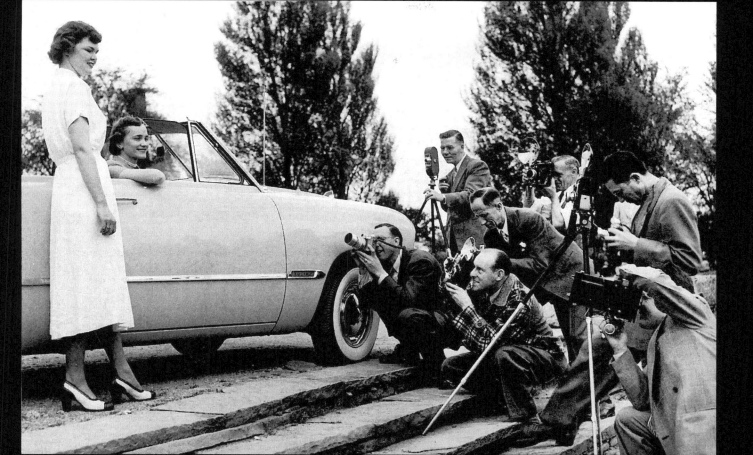

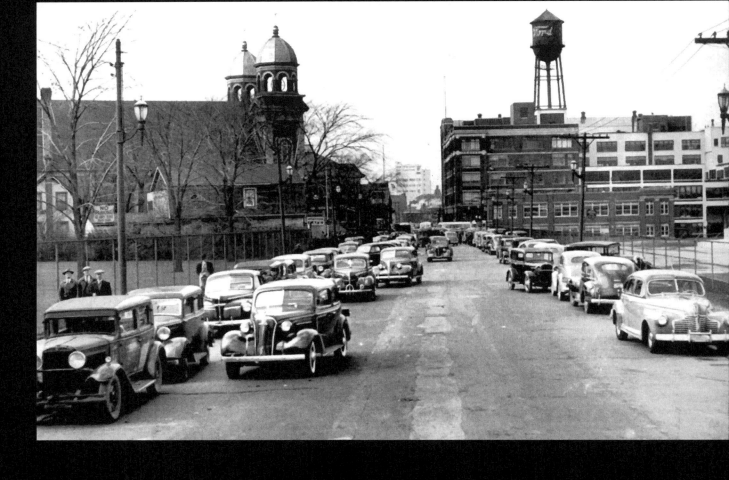

Ford Strike Along Riverside Drive at Drouillard Road

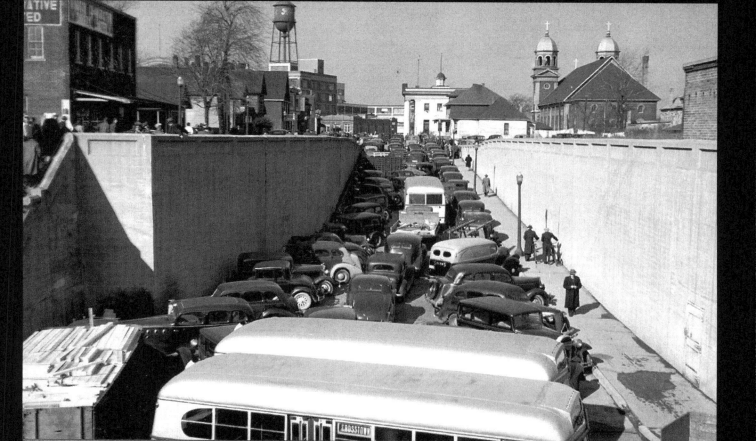

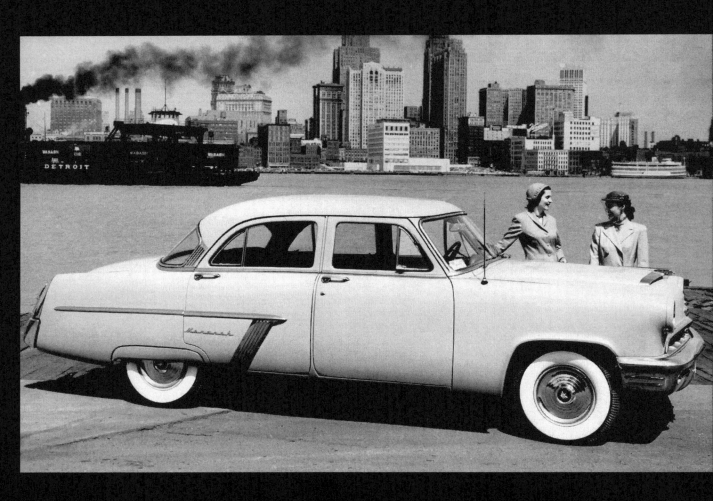

Buy Me a Mercury!

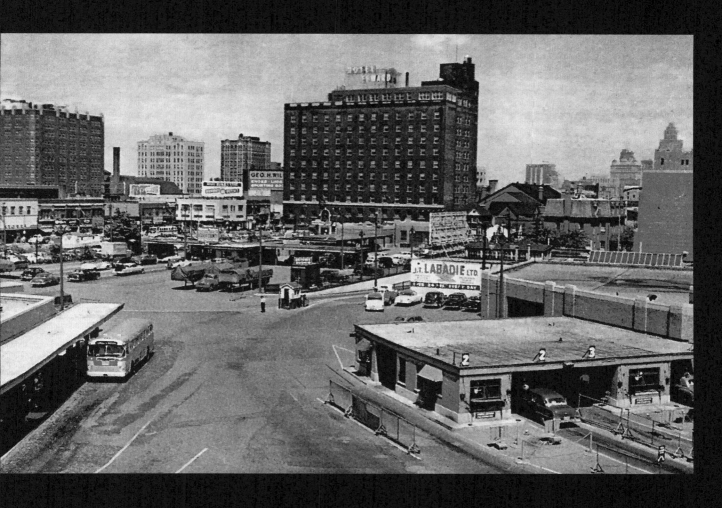

Tunnel Plaza, 1950s

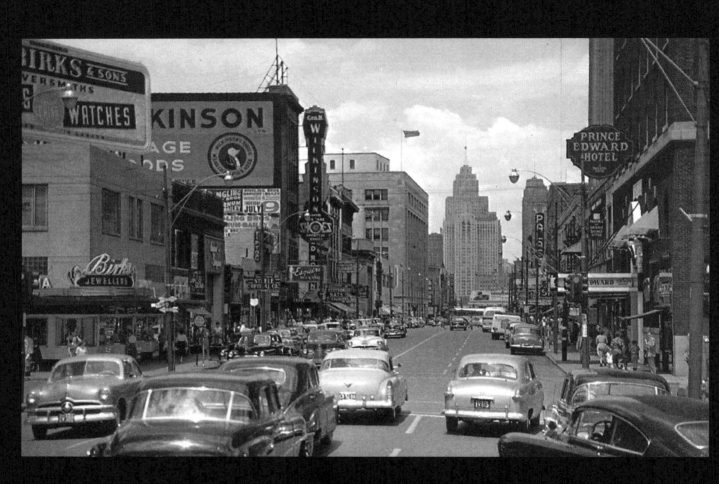

Main Street, 1950s

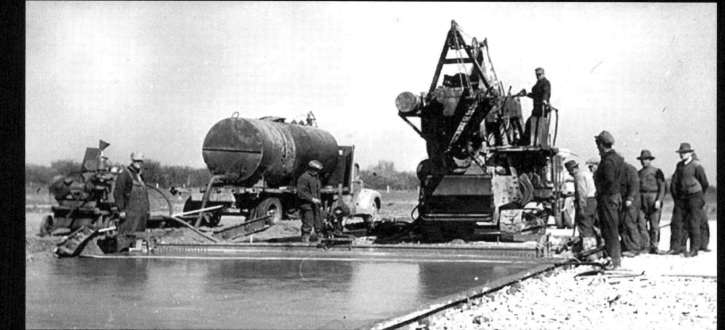

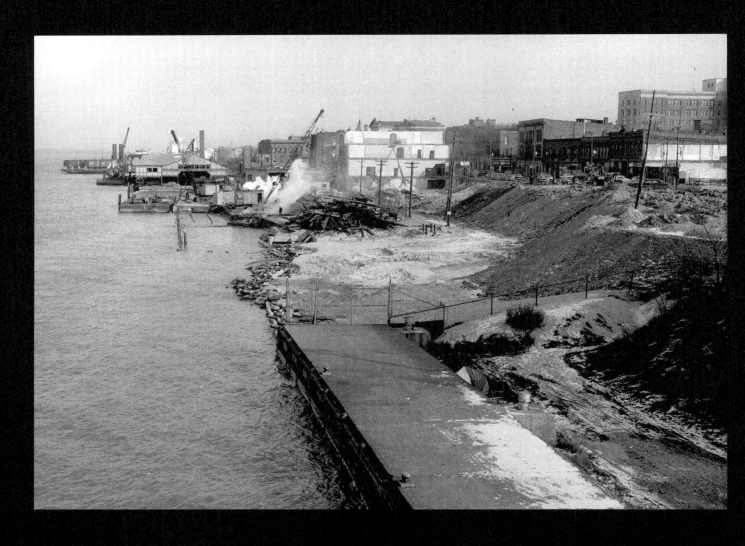

End of An Era Along The Waterfront, 1950s

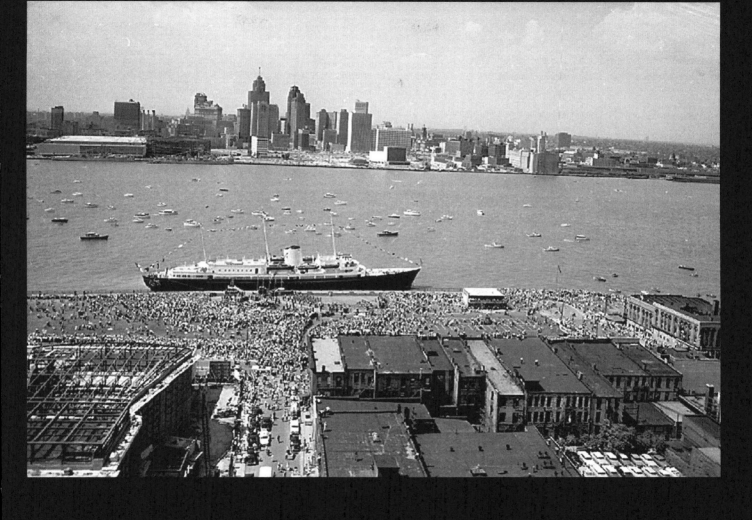
Queen Elizabeth Aboard The Britannia Tours Her Realm, 1950s

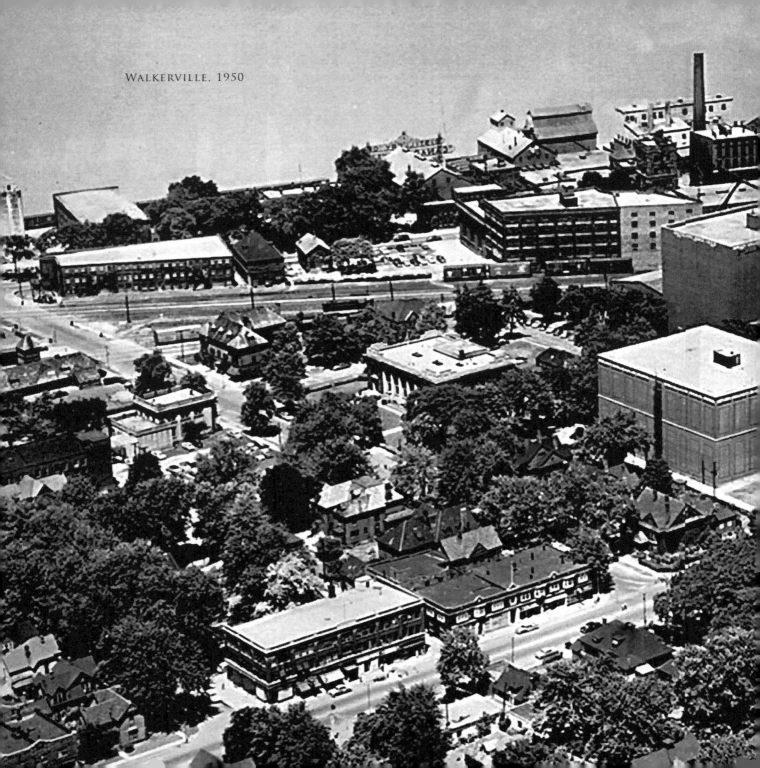
Walkerville, 1950

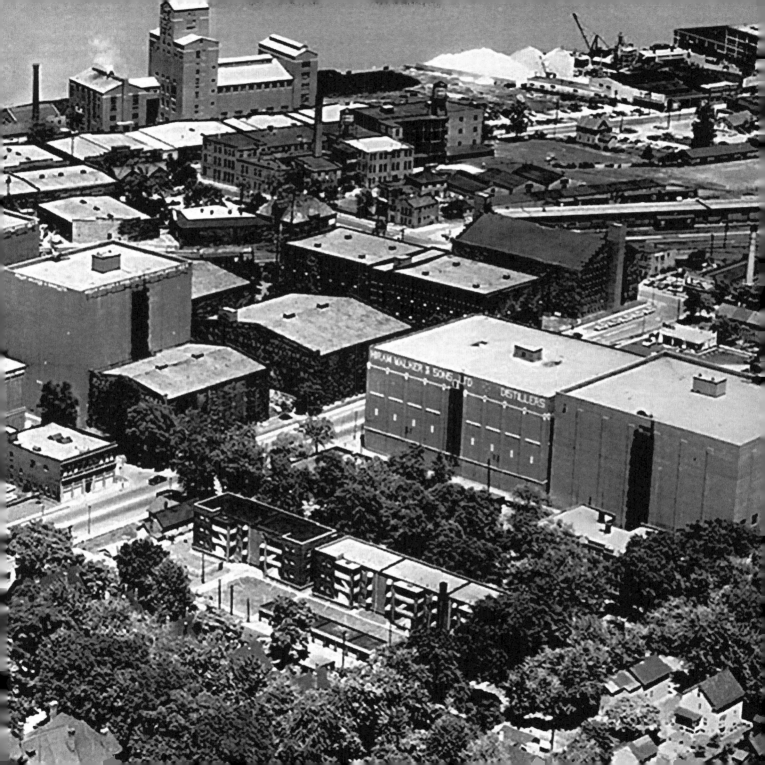

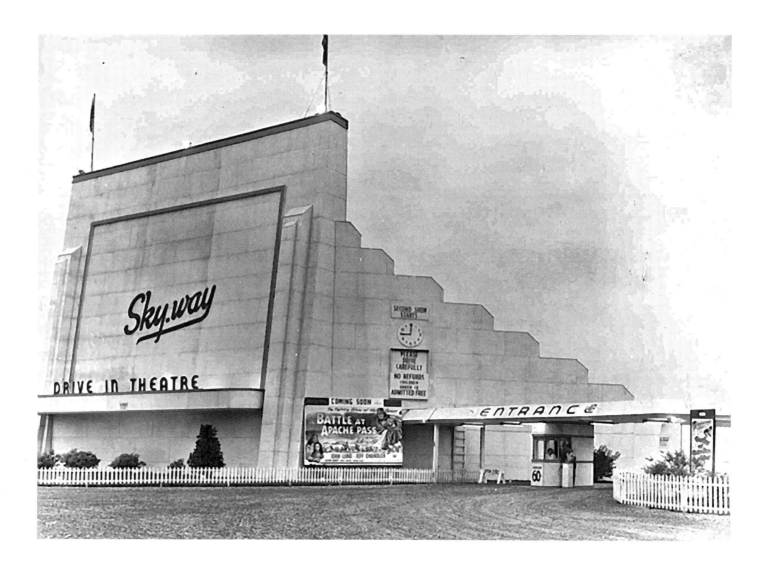

Made in the USA
San Bernardino, CA
28 October 2013